Exploring Hyperrealism

Drawing and Painting Techniques

© 2019 Promopress Editions
© Texts and illustrations: Martí Cormand
www.marticormand.com
© All photos in the book: Celeste Fichter and Martí Cormand,
with the exception of the photo on p. 118 (MoMA): Martina Cormand,
on p. 44: AdobeStock, and on p. 72 123RF
Editing and revision of texts: Bernat Cormand
Correction of texts: Montse Borras
Graphic design and layout: Alehop
Coordination: Rebeka Elizegi

ISBN: 978-84-16851-84-3
D.L.: B 16475-2018

Promopress is a trademark of:
Promotora de Prensa Internacional, S.A.
C/ Ausiàs March 124
08013 Barcelona, Spain
Tel: 0034 93 245 14 64
Fax: 0034 93 265 48 83
email: info@promopress.es
www.promopresseditions.com
Facebook: Promopress Editions
Twitter: Promopress Editions@PromopressEd

We are grateful to all the makers of the brands of professional instruments
and products that appear in the book.

Printed in China

Martí Cormand

EXPLORING
HYPERREALISM

—

Drawing and Painting Techniques

PROMOPRESS11

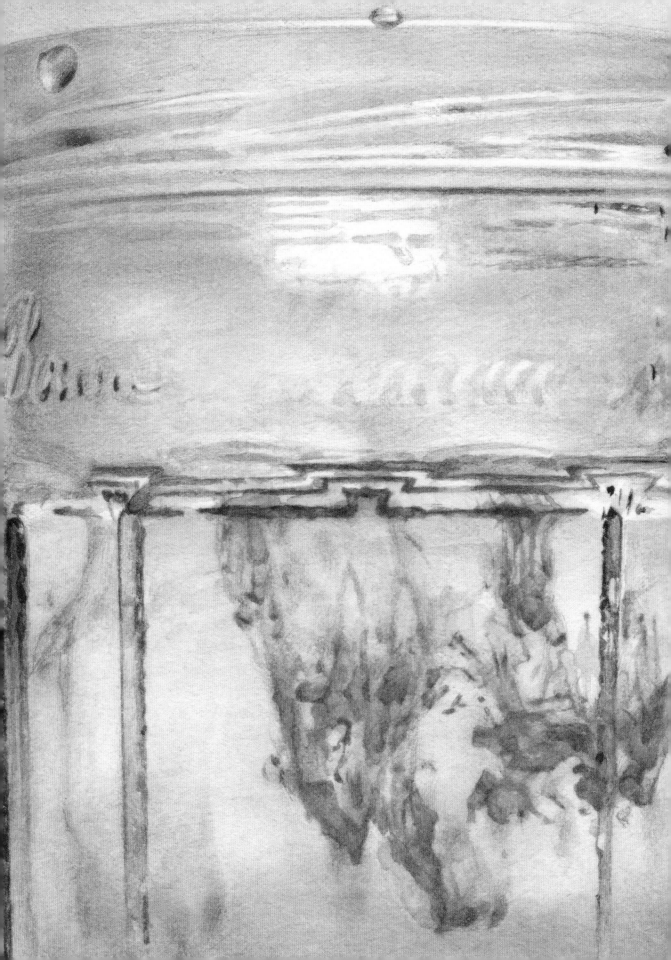

Contents

Introduction 06

1

DAWN
Pencil 12

2

MORNING
Coloured pencil 40

3

MIDDAY
Watercolour 56

4

AFTERNOON
Oil 78

5

EARLY
EVENING
Sculpture 100

6

SUNSET
A final watercolour 121

The author 126

Intro-
duction

An invitation
from a friend

A few months ago, I received an invitation from my friend Sarah, and I accepted it right away: while she was visiting her family in Australia, my wife Celeste and I could enjoy her home in California over the course of July. We would take care of the plants and flowers in its beautiful garden and of the orchids that decorate its living room. And, of course, we would provide company for Teegan, a black Labrador who tends to miss her owner, as well as for Mister, a cat who, although advancing in years, still heads off from time to time on adventures, disappearing for a few hours. The house is in a coastal village on the outskirts of San Francisco. The atmosphere is ideal for a contemplative life, but I would have a lot of work to do, so my days in this wonderful place would be spent studying hyperrealism.

This book stretches over a day, from dawn until nightfall. I will introduce you to hyperrealism by looking at four different techniques: pencil, watercolour, oil and sculpture.

© Martí Cormand

The last light_
Illustration produced for the final
chapter of this book, 2018
Watercolour on paper, 25.5 x 19 cm.

This book stretches over a day, from dawn until nightfall. I will introduce you to hyperrealism by looking at four different techniques: pencil, watercolour, oil and sculpture.

The scientist Benjamin Franklin once remarked that "a watched pot never boils" to explain how it feels as though time stands still if we focus on it. Our perception of time is subjective, and those of us who enjoy what we do feel that it passes by fast. I hope to share the same feeling with you.

Photorealism as a precursor to hyperrealism

By the 1920s, the painters involved in precisionism—also called "cubist realism"—were working with the help of faithfully reproduced photographs.

An example from this artistic movement born in the United States is the painter and photographer Charles Sheeler.

But pop art is nevertheless the precursor of photorealism and, by extension, of hyperrealism, as it uses the iconography of everyday life to produce the same neutral and static images.

Although they never converged in a group, the photorealists, who are sometimes called "superrealists", organized exhibitions in which the style was brought together—for example, *The Photographic Image* and *22 Realists*, which were both held in New York in the mid-1960s. The word "photorealism" was coined by Louis K. Meisel in 1968, and it appeared in print for the first time in 1970 in the catalogue for the Whitney

Museum's *22 Realists* exhibition. It should be noted that at that time in the United States, abstraction was the dominant trend, in the form of abstract expressionism and minimalism.

In photorealist works, the artist seems to be absent; the canvas is covered with a thin layer of paint, which is applied with a gun or brush in such a way as to avoid leaving any trace of brushstrokes. The canvas is even scraped with a knife to ensure the surface is completely flat.

Photorealism has now expanded into new technological fields –for example, three-dimensional computer-generated images.

Hyperrealism

In 1973, the Belgian artist Isy Brachot used the French word *hyperréalisme* as the title for a major exhibition at a gallery that he ran in Brussels and for its accompanying catalogue. The exhibition included the work of renowned American photorealists such as Ralph Goings, Chuck Close, Don Eddy, Robert Bechtle and Richard McLean, though well-known European artists such as Domenico Gnoli, Gerhard Richter, Konrad Klapheck and Roland Delcol were also featured. Since then, the term *hyperréalisme* has been used by European artists and gallery owners to refer to contemporary painters who have been influenced by the photorealists of the past. In any case, the aesthetic principles of *hyperréalisme* are based on those of photorealism.

However, there are significant differences between the two. The strictest photorealist painters tended to imitate photographic images. They often omitted human emotion, political values or narrative elements. In contrast, although hyperrealism is in essence photographic, often it takes a softer and more complex approach in terms of what is represented, depicting it as something alive. Objects and scenes in hyperrealist

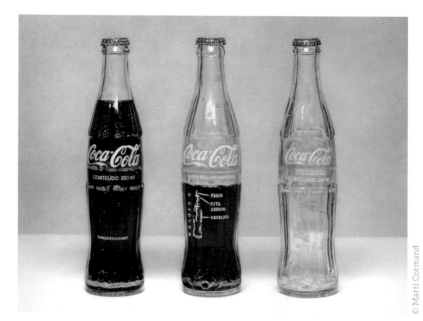

Formalizing their concept_
Cildo Meireles, *Insertions into ideological Circuits: Coca-Cola Project*, 1970
2013, graphite pencil on paper, 44 x 50.8 cm.

paintings, drawings and sculptures seek to create the illusion of a reality that cannot be seen in the original photo.

Hyperrealism also in part represents an evolution in the classical realist narrative, though its way of representing reality is more radical than realism is, since sometimes a photo is used as the pictorial model rather than reality itself. A well-known example in this respect is the artist Antonio López.

Hyperrealism à la carte

Although a single narrative dominated the art world in previous centuries, the arrival of

modern and contemporary art brought with it new narratives that have enriched earlier accounts. This new framing has provided an open field for artists, who have been able to explore their creativity more freely and break out of classicism's rigidity.

In contemporary art, the barriers between disciplines, techniques and even narratives are becoming increasingly fragile, and so many artists draw on all of them to convey what they want to express at a given moment. Hyperrealism is a technique that artists can use for specific projects or moments without becoming labelled as hyperrealists. This is my case. Another well-known case is that of the great painter Gerhard Richter.

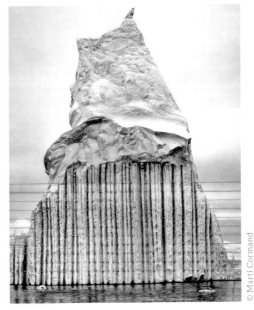

© Marti Cormand

© Marti Cormand

Formalizing their concept_
Sherrie Levine, *After Walker Evans, 5*, 1981
2015, graphite pencil on paper, 12.7 x 11.43 cm.

Pinstripe_
2008, Graphite pencil and watercolour on paper,
48 x 35.5 cm.

In this book, I will use different drawing methods: a light box for tracing, a grid and freehand drawing. You can choose the method that best suits you and, ultimately, your artistic attitude.

The use of tools

Tools cannot produce paintings on their own—for the time being. To a greater or lesser extent, we all use tools that make our work easier. The use of these resources does not have to be detrimental to an artwork's quality. From my point of view, there is no problem in opening up fields and accepting all methods as valid. The focus is not a debate about whether or not we should use certain tools, but one of how we build a world of our own based on experimentation and intuition.

In this book, I will use different drawing methods: a light box for tracing, a grid and freehand drawing. You can choose the method that best suits you and, ultimately, your artistic attitude. As the works made for this book are the actual size of the book, I will not consider the projection method, which is used mainly when working with larger sizes. It is easy to find tutorials for it on the Internet.

I usually use a light box to trace, but I also draw and sculpt from real life; it depends on the project.

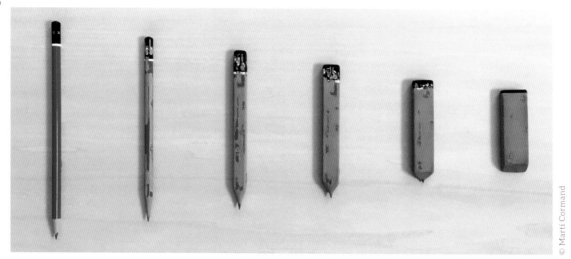

© Marti Cormand

Meeting Point: Pencil / Eraser H_
2017, mixed media (oil on wood), 20 x 61 x 6 cm.

The Hockney-Falco thesis

In 2001 in the Tishman Auditorium in New York, the British painter David Hockney presented the conclusions of his thesis on the use of optics in painting from the beginning of the Renaissance, which was the outcome of research he carried out with the physicist Charles Falco of the University of Arizona.

The conference was attended by historians, art critics, scientists, artists and specialists of all kinds, all of whom took part in the debate. While some were in favour of the Hockney-Falco thesis, others were sceptical. The controversy had already begun with the release of *Secret Knowledge: Rediscovering the Lost Techniques of the Old Masters*, which was first published in 2001, with an expanded English version released in 2009.

Hockney and Falco's thesis suggests that the progress made in realism and accuracy in Western art from the Renaissance onward was not due only to developments in painters' abilities but also to the use of optical aids such as the camera obscura, the camera lucida and curved mirrors.

Hockney's experience as a painter made him suspicious that compositions as extraordinary as, for example, those of Ingres could have been made in freehand without the help of any instrument. And so he began to experiment. First he did so with a camera lucida (a small glass prism that projects onto paper images that although blurred allow the artist to trace the main features) and then with a camera obscura (a closed box with a small hole through which light enters, projecting the external image onto the opposite internal side of the box). If we take day-to-day practice into account, it seems

to make sense that there has been a painter who—with the help of a physicist—has dared to question the opinion of many historians who argue that it was only at the beginning of the seventeenth century—and in specific cases such as Vermeer or Canaletto—that the camera obscura began to be used for painting.

Time: An essential tool

This book fuses three time frames: the book's time, which elapses over a day; the couple of months of production time that I took to complete the works in the book; and the reader's own time. If we take the position that the real time is the book's time, months of work take place in just one day, considerably less than the period suggested by Arinze Stanley Egbengwu, a Nigerian artist born in 1993, who estimates that it takes two hundred to three hundred hours to produce a work.

Colour as a psychological tool

Because in much of this book we will be working with colour, I would like to consider the psychology of colour, a field of study that analyses the effect of colour on human perception and behaviour. It is important in disciplines such as design, architecture, fashion, sign making, advertising and art.

Different people have different perceptions of colour, and it's even possible for the same person to perceive a colour in a different way at different times because, for example, of their health or some kind of medication. Because of this, we need a model or reference point against which we can measure the properties that allow us to identify colours.

Pure colour
Normally, when we refer to colour, what we are really thinking about is pure colour, which is each colour when no black or white has been added, as is the case in a rainbow. Pure colour can be altered. The three properties of colour are summarized below.

Colour properties

Hue
Hue refers to the continuum of pure colours. Hues follow a natural order: red, yellow, green, blue and violet. Each can be mixed with its neighbouring colours to produce a continuous variation from one colour to another. An

The human eye can distinguish between a considerable number of colours and colour combinations. Managing all of these combinations and creating a language that everyone can understand is important.

orange made by mixing red and yellow will have a different hue according to the amount of each colour used.

Value
Value is the level of light that we perceive in a colour. Colours that have a high value (that is, light colours) reflect more light, and those with a low value (that is, dark colours) absorb more light. To classify these levels of value, a scale ranging from white to black is used. We also refer to this quality as "lightness."

Saturation
Another colour characteristic is saturation, which refers to the intensity of a specific hue. A colour has maximum saturation when it has no black or white. In contrast, colours lose saturation if they have been mixed with grey, and this can occur to such an extent that the hue is barely perceptible. This loss of intensity can also occur by mixing the colour with its complement, which produces a neutral colour.

Pure colour

Hue

Value

Saturation

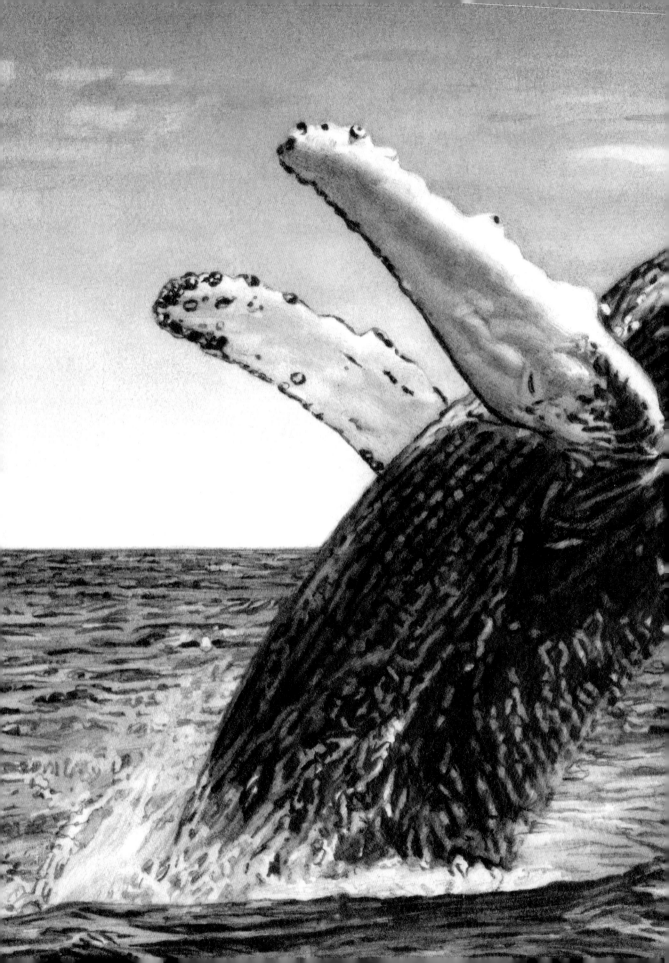

DAWN

Pencil
—

We fall asleep at night and wake up every morning. This is a fact of life, but it's an extraordinary one at the same time; it reveals to us what Octavio Paz called "the forgotten astonishment of being alive."

Every day over the course of July, Celeste and I have been getting up early. The reason: Teegan, a black Labrador who likes to have her breakfast at six-thirty each morning. She gets up onto our bed and stares at us until we wake up. She then makes noises and licks our hands, imploring us to feed her right away. Just as we start the day this way, we will begin our first exercises with the technique of graphite pencil. ∎

Materials

Pencils are just pencils until the time eventually comes when you realize that different companies make pencils that although seemingly similar are different in terms of their graphite. It's a good idea to ask around to find the brand that best suits you. Faber Castell is my favourite, though I can't explain why.

A graphite pencil gives you a wealth of tones that are ideal for producing hyperrealistic results. It is one of the simplest and most versatile drawing instruments, offering a myriad of options.

In my view, picking the right paper is paramount. Because of its hard and smooth surface, I always use: **Strahmore®, 500 series, Bristol, 4 ply, plate, hot press.**

Classification and grading
Pencils are classified according to a continuous grading scale in which variation is based on the degree of hardness and blackness.

As we can see on page 17, the current system of classification of pencils goes from the hardest (**9H**), which produces a thin and light line, to the softest (**9B**), whose stroke is thick and very dark.

Materials and instruments:

> Cutting board

> Strahmore® paper

> Drawing fixative

> Graphite pencils

> Adhesive tape

> Cutter

> Rubber eraser

> Pencil extender

> Pencil sharpener

> Graduated ruler

> Blotting paper

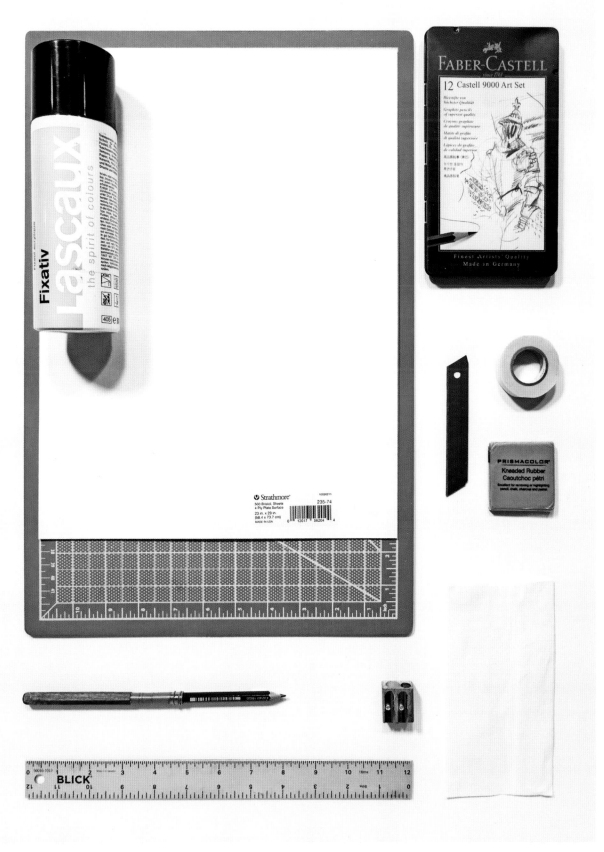

[Materials table]

Self-portrait

Self-portraits always hide a psychological component, as the historian and art critic Calvo Serraller describes: "Self-portraits have a beauty that is not about looks but rather about the psychological perspective of the sitter. It is a presentation of the individual's vanity and personality."

The self-portrait emerged at the same time as the mirror. Before that, there was only the surface of still water. In antiquity, mirrors were made of burnished metal, which was scarce and very expensive, but at the end of the Middle Ages a mirror made from glass and quicksilver was invented, and it spread rapidly.

We'll begin the first exercise before I get up by making a sleeping self-portrait, which is only possible with either imagination or photography. We'll do it with photography.

In the book *Secret Knowledge*, the artist David Hockney explains that, since the beginning of the fifteenth century, many Western artists have used mirrors and lenses to create projections of real life. Today, we use tools from our time. Here, I am using a light box to trace an image [A].

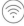

Some tips
If you do not have a light box, a window is an ideal resource. It is better if it is small and located in a dark room, as this will mean that the light from the outside is more intense, which will help you to see the image that you have decided to trace.

[A]

Pencils are classified according to a continuous grading scale in which variation is based on the degree of hardness and blackness.

Classification and grading scale of pencils

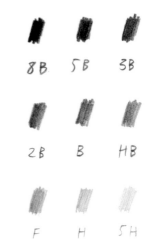

THE PROCESS

[A] With a 2B pencil and on a light box, we will produce a detailed tracing of the printed image on the back of the sheet of paper on which our photograph is printed; the result calls a map to mind.

[1 - 2] We then place this image on top of another sheet of paper with the side containing the photograph facing up and fix it in place with tape. With a 5H pencil and working forcefully, we transfer the lines that we traced onto the second sheet of paper by covering the entire surface of the photograph in pencil.

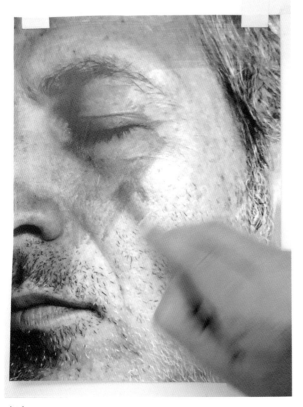

[1]

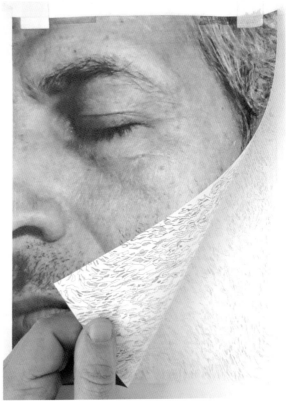

[2]

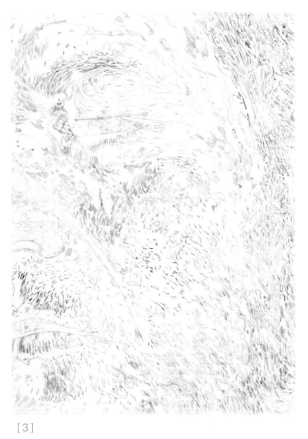

[3]

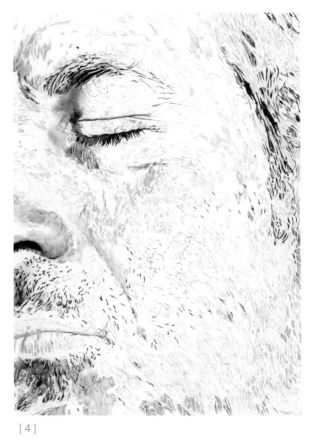

[4]

[3 - 4] Once we have the reference lines, we identify the darkest and lightest areas. We will use a B2 pencil for the darkest areas and an F pencil for the shadows that surround these dark areas. The drawing will emerge at different points of the paper.

[3 - 4 - 5 - 6] It is important not to saturate the drawing too soon; we will increase the intensity gradually. I often brush my finger across greyer areas to soften them.

If we have been drawing a long time, we should take a break. If we stare at something too long, the mind can play tricks on us.

[5] With an H pencil, we will draw more skin, leaving the whites of the hairs and taking into account the lighter tones from light reflected off the skin. It is important to remember that we are working with a real face and not with the image of a face.

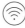

Some tips
If before beginning to trace we protect the margins of the drawing with an adhesive tape that does not mark or tear the paper, the rectangle that configures the drawing will be delineated and completely clean.

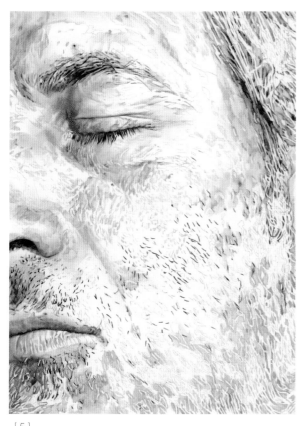

[5]

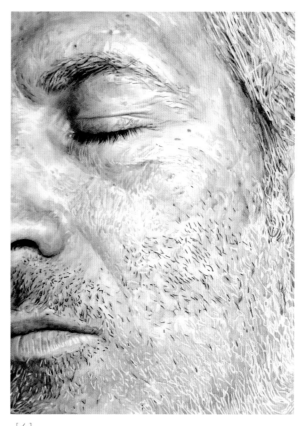

[6]

[6] With an 8B pencil we will render the most intense shadows, and with HB and F pencils we will intensify the tones that surround these darker areas.

Finally, with a 5H pencil we will attempt to produce the appropriate tones to achieve a smooth and natural relationship between light and shadow.

Some artists produce hyperrealism using a system similar to that of a printer: they start the drawing at the top and complete it by moving downward. I like to construct the drawing in a more organic fashion, as if it were decomposed but in reverse.

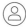

Other artists
Ron Mueck _
(Australian, born 1958)
In the work *Mask II* (2002), the sleeping face belongs to Ron Mueck, the artist behind this fibreglass sculpture that faithfully reproduces all the details of the human anatomy. His works focus on the themes of life and death and evoke an intimate and monumental realism.

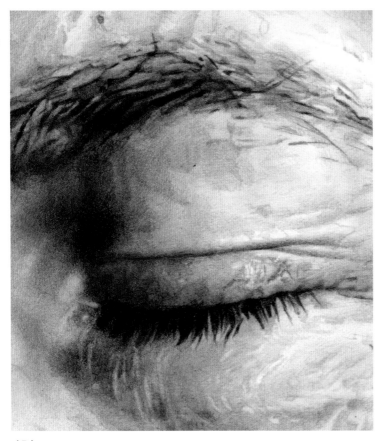

[B]

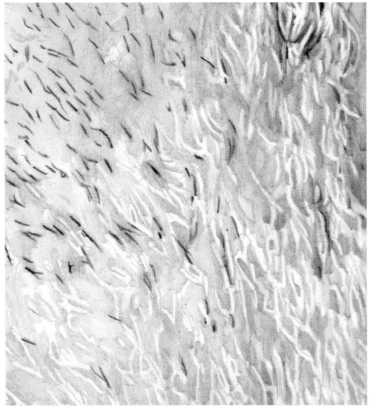

[C]

[B] **The eye is closed,** but we must bear in mind that the upper eyelid and the lower one, which are covering the eyeball, determine the volumes and, therefore, the light and shadow. The light comes from the right and the shadow is on the left side. To draw the eyebrow and eyelashes, we begin by using an HB, and little by little we intensify the black with a 3B, and with an 8B for the darkest hairs.

[C] **We obtain the white hairs of my beard by leaving the white of the paper.** We draw the shapes around the white with an F, an H and a 5H, and we produce the tones of the skin using grey values. Every hair is different, so we will produce them one by one and with a little bit of patience.

[Final step] **To protect the drawing** and prevent the graphite from smearing, we set the pencil with a special fixative for graphite.

When finishing up, it is important to fix the graphite with a professional fixative spray, thereby ensuring that our work will stand the test of time.

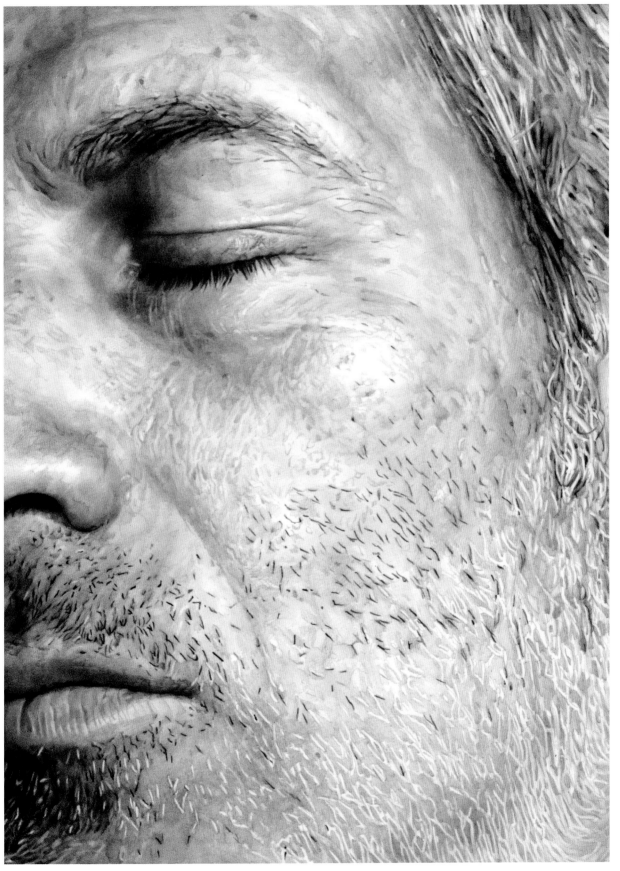

[The self-portrait]

The studio

The building that we are occupying over July is part of a group of houses built in the 1950s that all follow the same architectural template. Over time, the owners have transformed them with varying degrees of success.

Our friend Sarah's home is one of my favourites, because it has views of the Pacific Ocean, because from the street it retains its original shape and because the previous owner expanded the space with an extension at the rear. In addition, Sarah handled renovating it with exquisite taste. Celeste and I used the extension at the back as a studio. It is the room with the most light, the best views and access to the garden.

To reproduce the studio, we will construct the drawing as though it were an architectural project: the garden will be made with lines and the building in the hyperrealist style.

Nowadays, the world of architecture and architectural representation is dominated by computer programs that make it easier to draw plans, though it is true that it is a bonus for architects if they are proficient in all the "manual" techniques of architectural representation and expression [A].

Some tips

If we want to produce a sense of perspective in a straight line made with a graphite pencil and ruler, we can draw the line with an HB pencil, applying very little pressure to the most distant part, and gradually increasing the pressure as we move closer to the foreground.

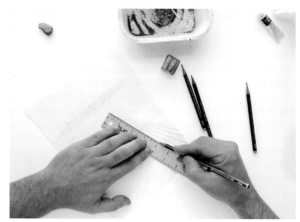

[A]

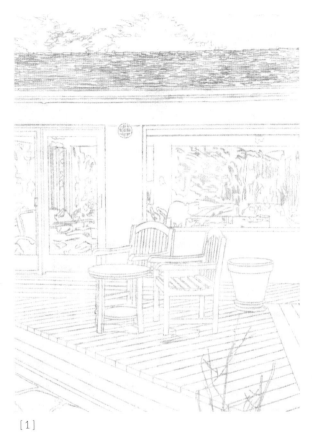

[1]

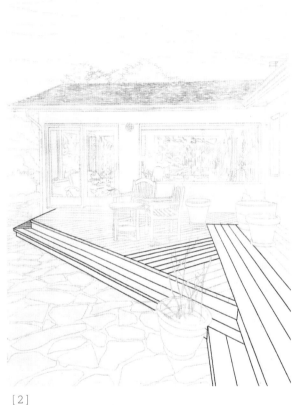

[2]

THE PROCESS

[1] Using the tracing system from the previous exercise (see page 17), we will trace the lines that will serve as a reference for the definitive drawing and transfer them onto the sheet of paper on which we will produce our artwork.

[2] Then with an HB pencil and a ruler, we will begin the drawing by retracing with more intensity the lines that will render the garden, as if we were a machine.

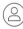

Other artists
Gina Heyer _
(South African, born 1983)
The painter Gina Heyer considers architecture from an emotional standpoint, creating disturbing atmospheres that evoke a certain nostalgia. If you have been in any empty institutional buildings, her paintings will seem familiar to you. From my point of view, her technique and attitude are closer to photorealism than they are to hyperrealism.

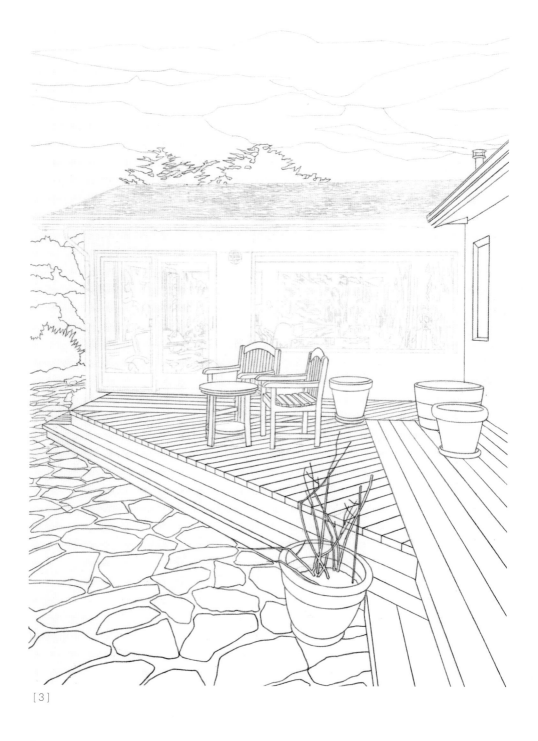

[3]

When we have perfected the lines that we have drawn for the garden, I recommend setting the drawing with fixative spray and protecting the area with a sheet of paper before starting to draw the building, so we avoid making any mess in the completed area.

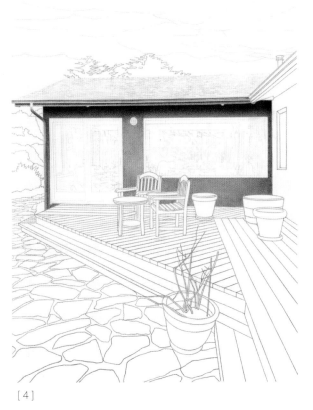

[4]

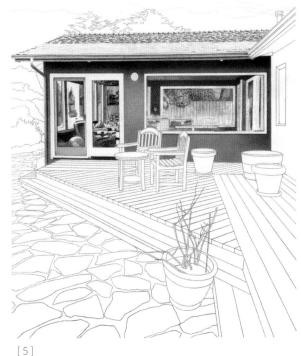

[5]

[3] **We will reinforce the sense of perspective** for the garden by increasing the pencil intensity and the thickness of the closest lines (the area with the plant pot with a plant in it and the larger slabs), and by reducing the intensity and the thickness of the more distant lines (the lines that are near the building, trees and clouds).

[4] **After we have finished the garden**, we will construct the drawing of the building starting with the front wall, with an H for the light tones, an F and an HB for the darker ones and a 3B for the black shadow produced by the roof.

We will blend the grey with our finger and use a 5H to polish the tones.

[5] **We use the ruler to trace the lines** for the front wall's windows and doors, and we will approach drawing their shadows with care.

Next, we will focus on the interior space, the windows and the garden at the back. We will draw the details with an H, the darkest tones with an HB and the blacks with a B or a 3B. It is important to fully appreciate what we are drawing: the sofa, the plants, the fence and so on. We will also begin the roof.

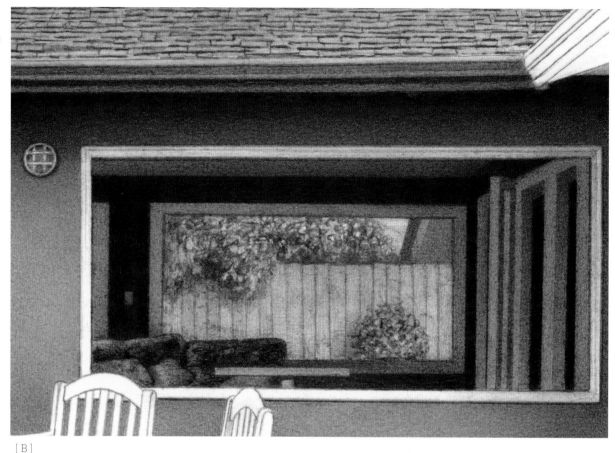

[B]

If our starting point is a photograph of a building, sometimes the camera distorts the straight lines. Photoshop is a tool that can be used to rectify strange effects such as this. You will find tutorials on this on the Internet.

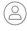

Other artists
Henri Labrouste _
(French, 1801 - 1875)
Henri Labrouste was a French architect from the famous École des Beaux-Arts. He was a pioneer in the use of iron structures. I was lucky enough to see an exhibition of watercolours and drawings of his projects at MoMA in New York, and I found them extraordinary.

[B] If we look carefully, we can see that the roof has a rhythm to it. There is no need to draw the lines of the tiles in the exact place that they occupy if visually we are sure about the rhythm of horizontal and vertical lines that makes us think that what we see is a roof.

[Final step] We will use a finger to blend and intensify the tones from the inside of the studio and from the roof so that they are darker. Going from dark to light, we will use 8B, B, HB, F, H and 5H pencils.

To draw or paint architecture, it is important to fully understand the spaces that we are depicting. The best way to do this is to work in situ and observe the place before you begin. But if you do not have the chance to do this, you can take a mental journey through the place to understand where its light comes from or to get an idea of the spaces behind windows that can be seen, as in the case of our studio.

[The studio]

With
sea
views

From the studio, the views—the garden surrounding the house, the cypress trees a little further away and the Pacific Ocean in the background—are spectacular.

In the ocean, there are blue whales and humpback whales that feed off the California coast. They spend the spring and summer here before heading to their winter breeding site near Mexico and Central America.

The whaling industry was a major economic force in both the United States and Japan, and each society captured this topic through art, though they did so in very different ways.

We will draw a humpback whale as it is jumping. Using our pencil, we will make time stop for an instant and we will study the sea, using a photo as a reference point.

In this exercise, we will freeze a moment in time: the instant when a humpback whale jumps out of the sea. And we will study the sea using a photograph as a reference [A].

Some tips
Let's remind ourselves of the differences between a soft pencil and a hard one.

> Soft pencil
 The graphite is thick
 It breaks easily
 It is possible to blend the strokes

> Hard pencil
 The graphite is fine
 It does not break easily
 It is not possible to blend the strokes

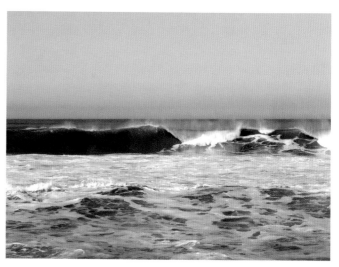

[A]

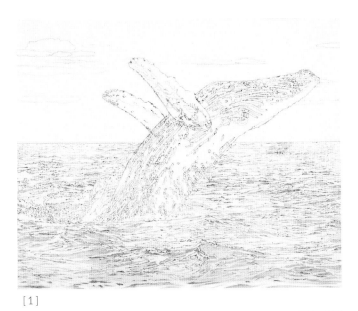

[1]

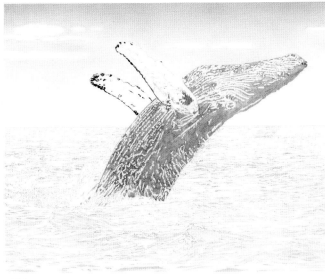

[2]

[3]

THE PROCESS

[1-2] Once we have lines on the paper with the help of a light box, we use an H pencil for the whale's first grey tone, leaving the splashes and the lines for the whale's skin blank. We will use a 3B for the black spots on the flippers.

[2-3] With a 5H pencil, we will render the tone of the sky. We will not apply much pressure: our lines will be drawn gently, and we will blend the space using a paper towel to produce a homogeneous gradation that goes from grey to white. To create the white clouds, we will use our eraser.

Erasers are another perfect tool for drawing [3], in this case to create clouds. First we will produce the gradation for the sky and then use the eraser to make cloud forms from the white of the paper. That is, we will draw by rubbing out. The diffuse texture obtained via an eraser is suitable for what we are attempting to achieve here.

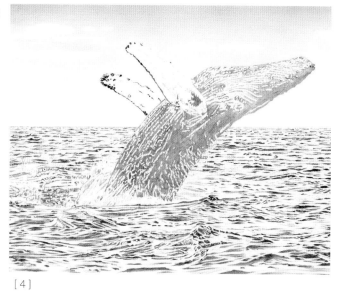

[4]

[4 - 5] Next, we will focus on the sea: we will use a 3B pencil for the blacks and an F for the dark tones, and we will render the gradation of the shadows from the waves. We leave the white of the paper for the points of light. The fizzing texture of the foam requires soft and careful pencil work.

[5 - 6] In this step, we will gradually intensify the shadow and light tones throughout the drawing; we will make the blackest shadow using an 8B. We will use an HB for the midtones, and an H combined with a 5H for light and very light tones. We will keep the water splashes white.

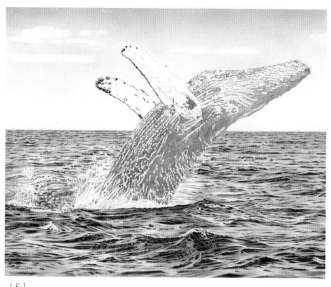

[5]

When we draw sea with a graphite pencil, the foam created by water movement provides a perfect contrast for the light and dark parts of the water.

Some tips

To ensure that the lines for the sea horizon are clean, I put down removable tape, and then I use my finger to apply graphite, simultaneously softening and intensifying the horizon. I then remove the tape.

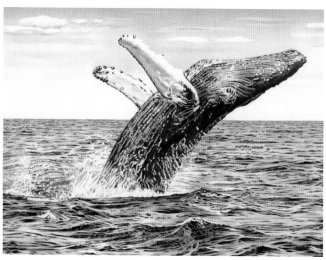

[6]

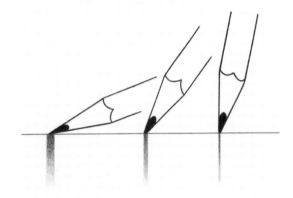

Some tips
It is said that an ordinary pencil
can produce a continuous line for a
length of over fifty-five kilometres.
When a lot of a pencil has been
used up and it is too small to hold
comfortably, a pencil extender is
the perfect solution [C].

[B]

The angle between pencil and paper can vary depending on what
we are trying to achieve [B - C]. When we are working with
large surface areas that lack detail (for example, backgrounds and
skies), the pencil will be almost parallel to the paper, and we will
use the side of the graphite to cover more of the surface area. For
areas that contain more detail, we will draw with the tip of the
graphite by placing the pen almost perpendicular to the paper.

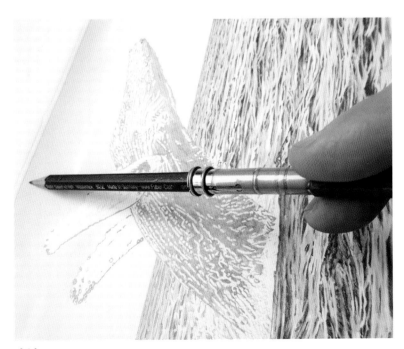

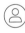

Other artists
Robert Longo_
(American, born 1953)
This Brooklyn-based artist
focuses on the idea of the frozen
moment in his *Monsters* series of
drawings of spectacular waves.
These large-scale pictures,
produced using charcoal on paper,
capture the moment before an
epic wave breaks. Robert Longo
started out studying sculpture
under Leonda Finke, who
encouraged him to devote himself
to the visual arts.

[C]

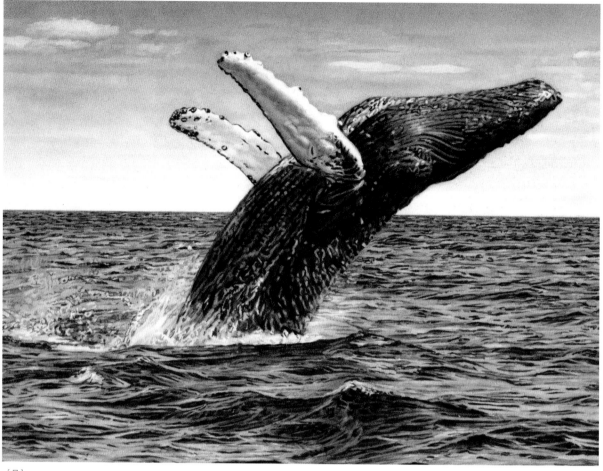

[7]

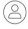

Other artists
Vija Celmins_
(American, born in Latvia in 1938)
I recommend Vija Celmins's famous pencil-drawn hyperrealistic drawings of natural elements such as the sea and starry skies. This artist's work fluctuates between the artisanal and the conceptual, between a scientific sensitivity and a poetic one, and between the macro and the micro.

[7] We will intensify the tone of the sky with an F for the dark part, followed by an H and a 5H for lighter tones. We will use an 8B pencil for the most intense shadows, and an HB and an F to intensify the tones surrounding these darker areas.

[Final step] Once we have identified the darker areas and those with the most light, it is time to soften and unify the midtones to achieve the right relationship between light and dark.

The final picture is a tribute to *New York State,* a work by American photographer Kenneth Josephson from 1970.

[With sea views]

Grattage with **Teegan**

Teegan began training to be a guide dog, but she couldn't complete it because of the physical problems that she has had from birth with her hind legs. Sarah rescued her, and since then she has been her trusty sidekick.

This month, Celeste and I have been taking care of her. She's a loving dog, and we love having her around us. Since Teegan is a black Labrador, she offers the perfect chance for us to work on the grattage technique if we create a dark background and light up her face with a spotlight.

It may seem strange to include grattage in this section, but really what we are talking about is drawing: we'll be working in black and white and with lines, though things will work in reverse in comparison to the rest of the exercises.

We will use a pencil to fix any mistakes that we might make during the process.

Pencil work involves producing shadows and leaving the white of the paper for points of light. But with the grattage technique, we create light by revealing white and leaving the background black for shadows.

Some tips

If we make a mistake, we can always retouch things with an HB, B or 2B pencil, or even black acrylic, to cover or obscure the lines or white areas that we do not want to keep or that have turned out to be too intense.

[A]

THE PROCESS

[A] The ideal instruments for grattage are an engraving pen or a scalpel, which is cheaper and easier to obtain. We will also need a sewing needle for the smallest details.

[1] To begin, we need a wooden board prepared with gesso that is suitable for the acrylic that we have purchased from a specialist art store. Using sandpaper with a very fine grain, we smooth the surface of the gesso and paint it with two or three thin layers of black acrylic. The end result will be a smooth matt black.

[2] Next, we need an HB Pencil, which we will use to produce a line drawing of the dog over the black acrylic. Then, using our engraving pen or scalpel, we begin with the hairs on the area around the snout by scraping at the black, which we do carefully.

The more pressure we apply when scraping, the more intense the white hiding behind the black will appear. This white intensity that comes out of scraping the black paint is equivalent to the intensity of light that we want to depict.

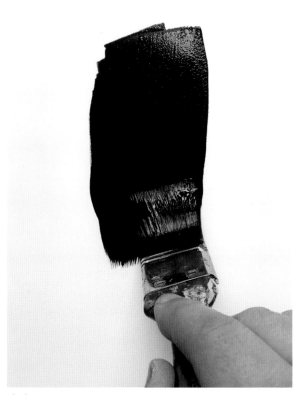

[1]

[2]

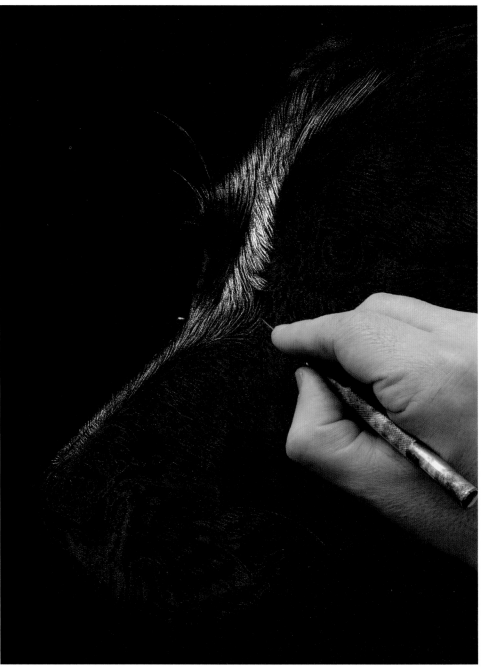

[3]

To produce gradations, we need to keep two things in mind when making each stroke on the black surface: the pressure applied and the angle of the engraving pen or scalpel.

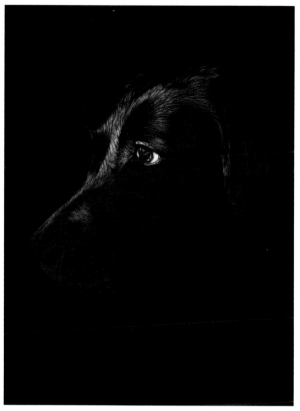

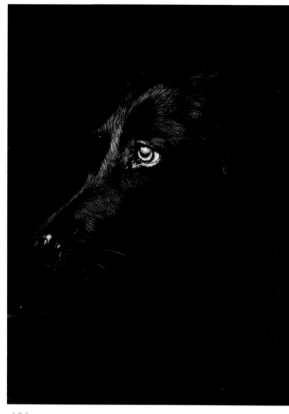

[4]

[5]

Grattage emerged in the 1930s as part of surrealist painting;
it was used by Max Ernst and Joan Miró. Later, artists such as
Antoni Tàpies also used it in pictorial informalism.

[3] **We will produce midtones** by scraping the
black with a greater or less degree of pressure.
One way to familiarize ourselves with the grattage
technique is to think about how the strokes we
would usually have drawn in black will now be in
white.

[4 - 5] **Each line is a hair that light is falling
on,** and we give form to the head using different
degrees of intensity of white. We will start to
bring out the white of the eye.

[5] **The white that results from scraping
away the black represents light.** The greater the
intensity of the white, the greater the intensity of
the light. At this stage, we will focus on the two
points with the most light: the eye and nose.

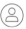

Other artists
Francisco de Goya _
(Spanish, 1746-1828)
Hanging in the Prado Museum is one of my
favourite paintings by Francisco de Goya:
The Dog. All that you can see is the small
head of a dog that is lurking behind a dark
patch. Everything else is a big empty space.
A few white strokes on a black background
produce the creature's face and expression.
The idea of producing only light against a
black background fits in with our exercise.
The Dog is one of the "black paintings" that
partly decorated the walls of the house
called Deaf Man's Villa that the painter
himself acquired in 1819.

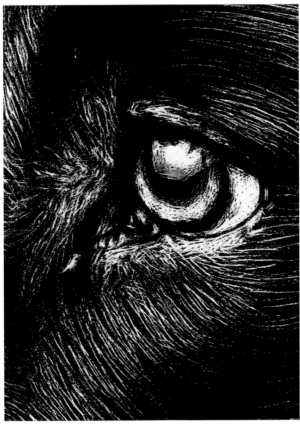

[B]

If we are working with a scalpel, it is important to change the blade fairly regularly, as doing so will keep our stroke clean and maintain the precision necessary to achieve a hyperrealistic result.

[B - C] The eye and nose. As I have already mentioned, these two points require the greatest detail.

Taking note of the level of detail of the bright parts of the nose, we will use the needle to produce the smooth gradation that can be seen in the image.

We need a needle to achieve the richness of tones of the bright parts; we are working on too small a scale to be able to use a scalpel or engraving pen.

[Final step] To finish off, we intensify the areas of medium brightness and the whitest parts by pressing down harder with the engraving pen or scalpel, taking a lot of care, as we always do with this technique, to avoid mistakes that can't be fixed.

The scraper is a tool that it takes time to get used to. It can be used on many supports, such as board, canvas and paper. It is often used on rigid supports, but it also works well with others.

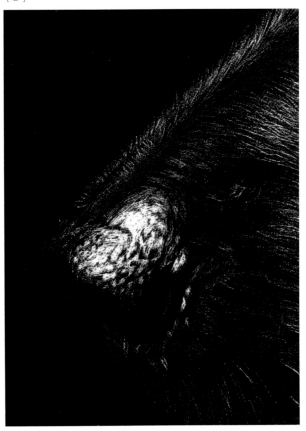

[C]

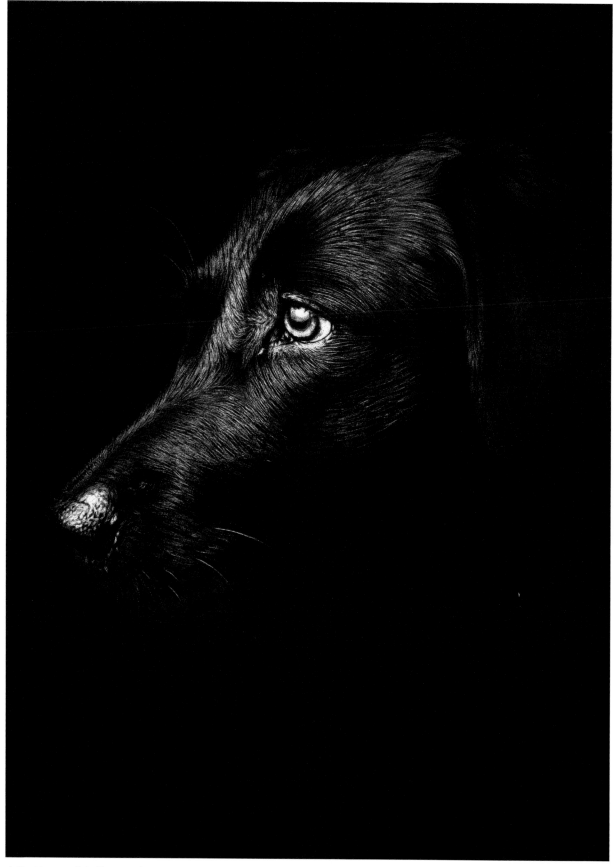

[Grattage with Teegan]

MORNING

Coloured **pencil**

In the morning, we sometimes hear the sound of an air horn coming from the beach. This means that there's a surfing event going on. Surfing culture is deeply rooted in these parts, so much so that people here organize extraordinary events of the kind that we'll see here in a couple of days: the World Dog Surfing Championships! We were curious and did some reading on the subject: it turns out that dog surfing events are new and very popular. They take place every year on California's beaches, and the proceeds from them often go toward supporting animal shelters.

While the dogs are competing, we'll continue to do our own thing: developing our hyperrealism techniques further by learning to work with coloured pencil, an exciting medium that allows us to produce very detailed and precise illustrations. ∎

Materials

Unlike graphite pencils or charcoals, coloured pencils are based on wax or oil, along with varying proportions of pigments, additives and binders.

There are also water-soluble colour pencils and pastel pencils. In general, there is no difference in quality between the different kinds, though some manufacturers say that wax or oil ones are brighter. For this exercise, we will use Faber Castell's® Albrecht Dürer pencils, which are of a high quality and come in a rich variety of colours. We will also need a white charcoal pencil (in this case, General's® Charcoal White 558), which is very useful for lightening tones.

In the first exercise, we will use the same kind of paper that we previously used with a graphite pencil (Strathmore® 500 series, Bristol, 4 ply, plate, hot press). And in the second exercise, in which we will combine coloured pencil and watercolour, we will use the following paper:
Arches®, watercolour, satin grain, 300 g.

For this exercise, we will use Faber Castell's®
Albrecht Dürer pencils, which are of a high
quality and come in a wide variety of colours.

Materials and instruments:

> Cutting board

> Arches® paper

> Strathmore® paper

> Coloured pencils

> Charcoal pencil

> Box of watercolours

> Round brushes

> Tube of black watercolour

> Cutter

> Rubber eraser

> Adhesive tape

> Graphite pencil

> Pencil extender

> Pencil sharpener

> Graduated ruler

> Blotting paper

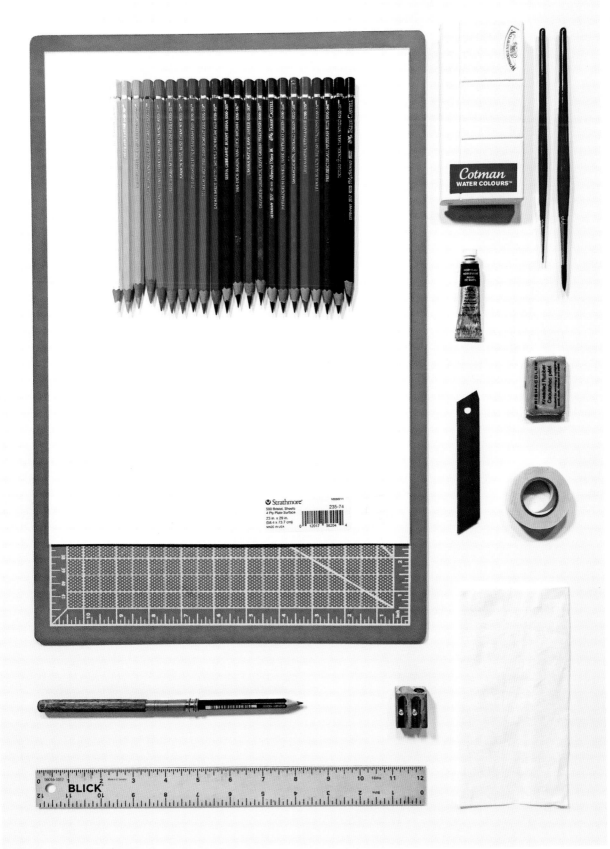

[Materials table]

Sharpening
a pencil

The importance of a sharp pencil

It is necessary to sharpen pencils correctly, as the shape of the tip will to a large extent determine the quality of the drawing.

Electric pencil sharpener

Insert the pencil into the hole, positioning the lead in the centre to produce a standard cone shape. As the pencil is sharpened, you will hear a buzzing sound.

Manual pencil sharpener

Place the pencil into the hole and rotate the sharpener several times to obtain a sharp point. Unless the sharpener has a plastic box designed to hold the pencil shavings, it is best to hold the sharpener over a container when using it.

We will draw the shavings with coloured pencils [A].

If we want to obtain a sharp, cone-shaped tip for detailed drawing, we can always refine the tip by carving it with a cutter.

Some tips

A good trick when it comes to sharpening a pencil whose tip is a little worn down is to use a medium-grit sandpaper, as this means that we don't have to go through the more laborious process of sharpening it.

[A]

THE PROCESS

[1] We will do an observational drawing of the shavings from our pencil.

Using a 5H pencil and a ruler, we will draw two perpendicular lines that cross in the middle of the paper; these will serve as a guide to maintain the proportions of the drawing.

Observing the shavings closely, use a graphite pencil to draw the outlines first and then the detail.

[2] With a cadmium yellow, colour the yellow at the edges of the shavings, and with a 5H pencil, an H pencil for the light tones and an F and an HB for the dark tones, draw the shadows, making them soft and blurred.

We must make sure that the shadow lends depth to the object. If we fully appreciate this depth from the outset, it will help us to understand the shape of the object, which we will render through light and dark tones.

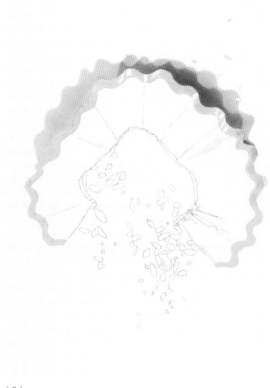

[1] [2]

[3]

[4]

[3] Then, working with our chosen colours (a mixture of browns, cadmium red pale and olive green), we will produce the details of the wooden shavings' irregularities: microlines, points and imperfections that define the nature of the material.

Use a cadmium yellow to render the smaller flakes.

Some tips
Holding the pencil correctly is essential if we are to be in control of our drawing. Hold the pencil between the thumb, index and middle finger. Do not apply pressure with the index finger or curl your fingers more than necessary.

[4] We then locate and work on the areas of light and shadow of the yellow part and the wood. As we do so, we must always pay attention to the texture of the material and observe the original shavings from our pencil.

We must focus on the wealth of tones: orange or reddish browns, greens and some black parts in the areas of shadow, as well as light orangey browns, yellows and bright white points in the areas of light.

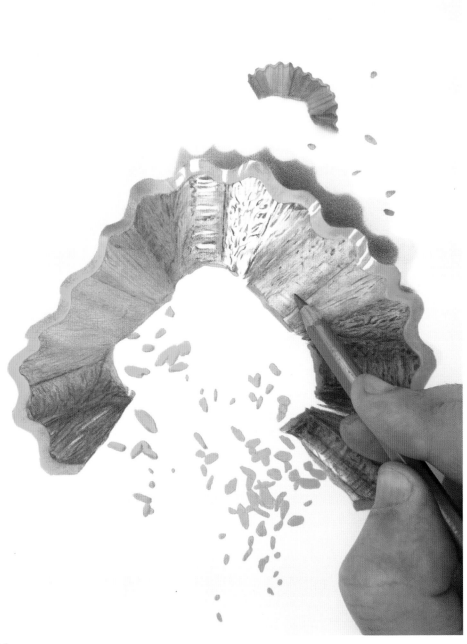

[A]

At times, our own working process provides
us with surreal and unforeseeable images
such as this one [A]. These may well serve as
inspiration for a future project.

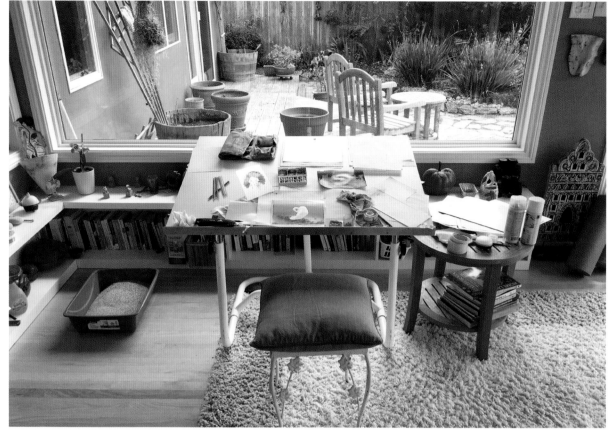

[B]

The shadowed areas of a picture are the parts that have not been or have only partially been touched by light.

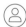

Other artists
Catherine Murphy_
(American, born 1946)

In this section, I would like to introduce the realist painter Catherine Murphy. I like her observational work and, above all, her choice of themes and framing. She depicts themes that, in spite of their being a ubiquitous part of our day-to-day lives, we do not pay attention to.

[B] The sense of volume that we want to give the object depends on how we choose to focus light on it. Full light and no shadow will often result in flatness. The shadows of our model are the result of light from a window and focal lighting. Natural and artificial light forms are not incompatible with one another, and they can be complementary if we use one as the main light and the other as a fill light.

[Final step] We will intensify the dark parts of the shadow cast by the shavings on the table with a B pencil, and using the same range of colours as before and producing circular movements with our coloured pencil, we will go back over the shavings so that the pencil strokes can't be seen. We will do the same with the smaller bits of yellow shavings.

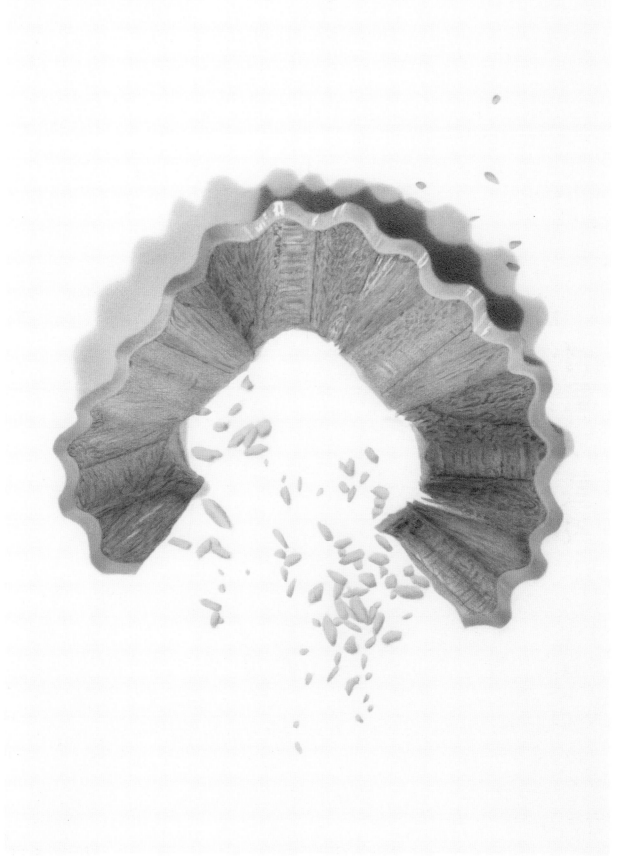

[Sharpening a pencil - Shavings]

Hannah's
<u>portrait</u>

Hannah is reserved and likes things to be done her way. For example, if you peel a banana for her and you don't do it the way she likes, she won't eat it. Benjamin, a boy with a strong constitution and an explosive character, is her brother. They're twins, though there are tiny differences between them; Hannah decided that she should be born first. Sarah's daughter Jenny is the mother of these children. They're about to turn two, and Celeste and I thought that to celebrate we would make portraits of each of them as a present.

Portraits are a way of freezing time: the children will grow up, but the portraits will remain as they are.

In this exercise, we will focus on Hannah's portrait, and we will use two related techniques: coloured pencils and watercolours in pan form. Together, they can produce great results.

We will use the following paper: **Arches®, watercolour, satin grain, 300 g.**

If we use a photograph as our starting point for making a portrait, it's not the case that any image of the model will do. It is essential for there to be a good contrast of light and shadow. Ideally, we should know the person whom we want to portray well, and the photo should become our point of view [A].

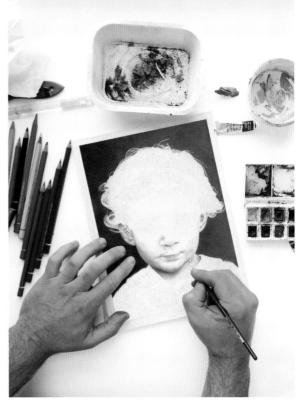

[A]

THE PROCESS

To prevent the paper from warping when we paint with watercolour, we first place it under a water tap and wet it on both sides. Then, working quickly, we use tape to fasten the edges of the paper to a smooth wooden board. We then wait two hours for it to dry fully.

[1 - 2] Once everything is dry, we will first of all draw Hannah's face in pencil. We will draw all the details of her face, and then we will paint the background in a brown tone that will be very diluted in water so that it's possible to appreciate the liquid texture of the watercolour.

[2 - 3] With a Van Dyke brown pencil, an olive green one and a black one for the shadow, and with toasted sienna, olive green, creamy yellow and white for the areas of light, next we intensify the initial layer of watercolour that we painted in the previous step.

Among the oldest portraits of particular individuals who were not either kings or emperors are Egypt's Fayum mummy portraits, which survived over time in the country's dry climate.

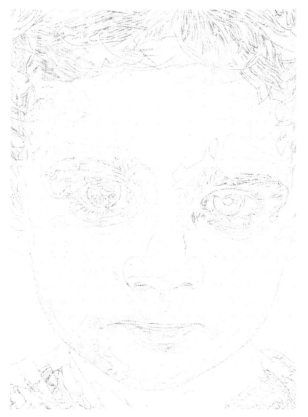

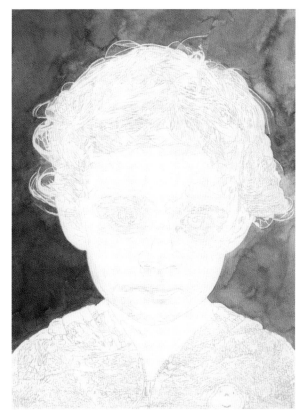

[1] [2]

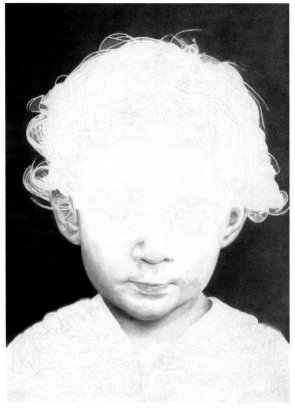

[3]

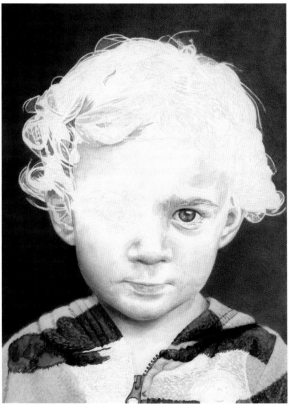

[4]

[3] We will use red, blue and grey watercolours to produce watery tones around the chin, mouth, nose and ears. Keep on the table a jar of water for washing the brushes and another for watering down colours. Hold the brush in one hand and blotting paper in the other.

[4] We next use red, orange and blue watercolours to gradually build up the face's cool and warm tones. Then, with a fine brush we will add the texture and colours for the bluish-green and cool-brown sweater, making sure that we continually keep in mind its different elements: the metal zip, the fabric of the sweater and the monkey. Using the same brush, we then begin to produce the eyes with great care.

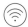

Some tips
Mastering light and shadow is more important than replicating the exact colours of the skin; light and shadow are essential for producing a face's volume and achieving a three-dimensional appearance.

Watercolour pencils have characteristics that make them suitable for achieving good results, with or without water.

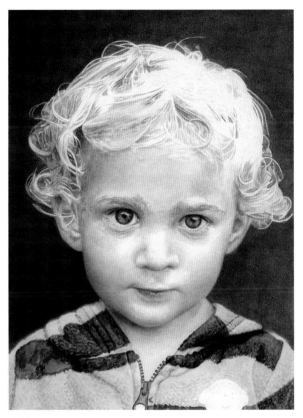

[5]

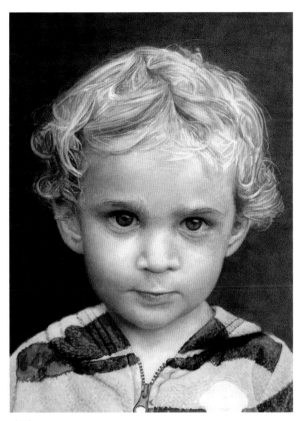

[6]

[5] We now have Hannah's features, and the tones of the face are appropriate. We will leave the contrast for the next step and focus instead on the hair. We will combine watercolours (greenish yellow for the areas of light, and orangey and greenish brown for the areas of shadow) with coloured pencils (olive green and Van Dyke brown) for details. With finesse and patience, build up the curly blonde hair.

[6] In the first stages, we applied the wettest watercolour, with blotting paper in hand in case we applied too much. In contrast, in this step we will apply a drier watercolour to define the tones. We're going to strengthen the shadows and midtones of the hair, face and sweater, making sure to always leave points of light. And with the black pencil, we will strengthen the dark areas of the eyes.

Adding a little honey to watercolour before painting gives the paint consistency and also preserves it and protects it from dust.

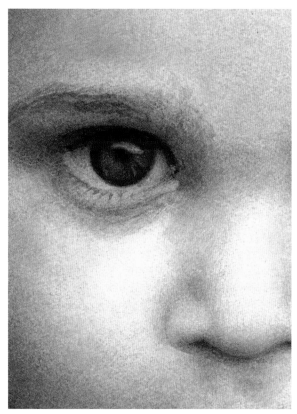

[B]

[C]

[B] **When working on the eyes,** it is important to take into account the wet and crystalline surface of the pupil, which reflects the external light. At the same time, the fixed eyelid overshadows the top of the pupil and the eyeball. Hannah's eyes have a honey-green colour.

[C] **Although at first sight Hannah's hair looks blonde,** it in fact contains many colours; for example, we find a

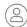

Other artists
Basil Hallward _
I would like to recommend Basil Hallward, an outstanding portrait artist, even if he is a fictional one: he is the painter who creates the mysterious portrait of Dorian Gray in Oscar Wilde's famous novel.

wealth of greenish tones that combine with some brown and yellow ones and with the white of the points of light.

[**Final step**] **We will intensify all the shadows of the face and hair** and soften the transition from shadow to light so that it looks natural. With a white charcoal pencil, we enhance the tones of the most luminous area of the face. Finally, using white charcoal again and a sharp tip, we highlight the shiny parts of the hair. Use a 5H graphite pencil to soften shadows where necessary. We then finish off the sweater, leaving the monkey for last.

A white charcoal pencil will serve to enhance the tones of the most luminous areas of the face and hair.

[Hannah's portrait]

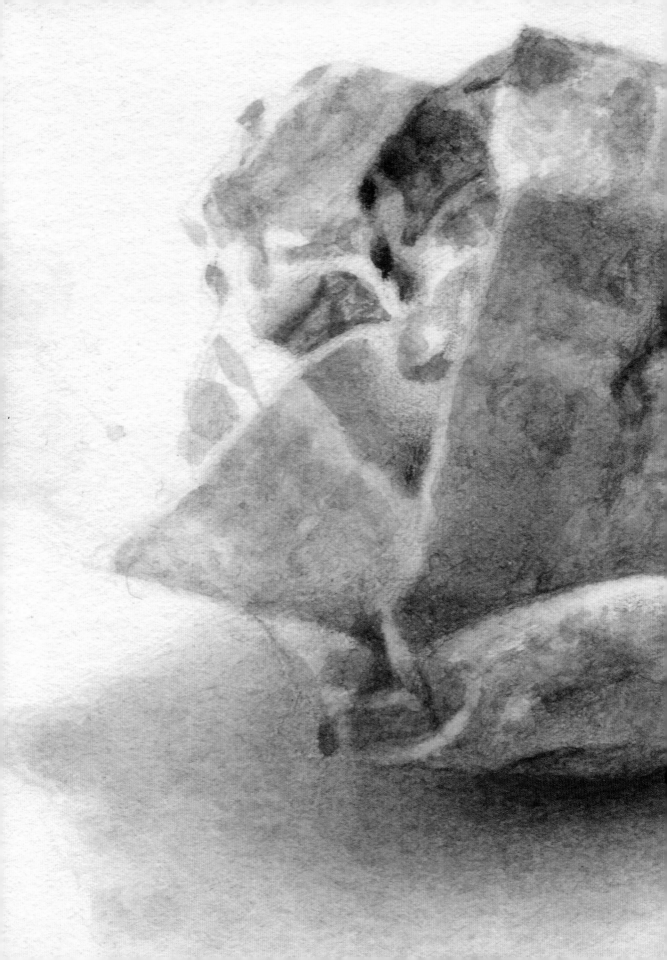

3

MIDDAY

Watercolour

It's eleven in the morning, and the garden is wet. But there hasn't been any rain; it's from a weeping fog that appears here frequently during the summer: the famous San Francisco fog. It creates an ideal environment for this section, as water is going to be paramount here.

Because watercolour is transparent, it allows us to create different hues and transparencies by diluting it with water. ∎

Materials

Paper
If we do not work on paper that is suited for watercolour, the water might deform and damage it. I use the following paper: **Arches®, watercolour, satin grain, 300 g.**

Pocket watercolour box
The Winsor & Newton® Cotman watercolour pocket box is a high-quality set that is ideal for painting while travelling or when outside, as it's about the same size as a mobile phone. The pans can be replaced individually and without having to buy a whole box of watercolours again. There is no black colour, but one can be made by mixing dark grey with blue and brown, or you can just buy a tube of black.

Brushes
There are many good brands to choose from, some of which are more expensive than others. I usually use a fine brush for details, a medium one, and a large and flat one for large surface areas.

Adhesive tape
I use Nichiban® 533, a Japanese tape, but there are others makes that are also fine.

You'll see that in the presentation of the materials the box of watercolours is closed. This is to create a story involving the exercise that follows. I invite you to discover it for yourselves.

Materials and instruments:

> Cutting board
> Watercolour paper (300 g)
> Glass jar
> Adhesive tape
> Box of watercolours
> Two round brushes
> One flat brush
> Tube of black watercolour

> Cutter
> Graphite pencil
> Pencil extender
> Rubber eraser
> Pencil sharpener
> Graduated ruler
> Blotting paper

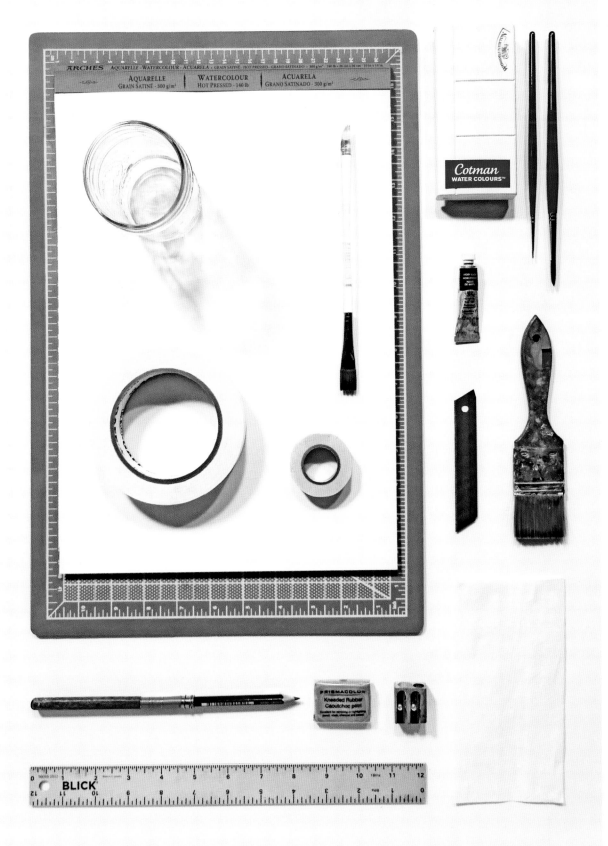

[Materials table]

Box of watercolours

Watercolour is made of a fine pigment or ink that is mixed with gum arabic to give it viscosity. You can find it in tubes or in pans.

William Reeves began to produce watercolour pans in the United Kingdom in 1766, and these ended up being sold commercially. These premanufactured pans meant that it was no longer necessary to release powdered pigments or other impractical materials for tempera and watercolours into the open air.

Pan/tube

For pans and tubes alike, the quality will depend on the pigments that have been used to produce the paint. Pans can dry out, so it is advisable to put them away when you have finished, covering them with a damp cloth before closing the box. Working with watercolour in tube form will mean our brushes wear out less quickly, because tubes remove the need to rub the brushes against a hard surface.

The reflection of light is an optical phenomenon that is caused by the different trajectories taken by light when it comes into contact with a surface or passes through a transparent body. **Specular reflection** takes place on a smooth, polished surface such as a mirror. This is the case with the brush and the box. **Diffuse reflection** occurs on a rough surface: light hits an object and diffuses in it, as is the case with the blotting paper.

Some tips

To achieve straight lines for the box of watercolours, we can make protected areas with adhesive tape. We attach the tape, apply our paint and then remove the tape.

[A]

THE PROCESS

Before we begin to apply watercolour, we have to prepare the paper in the same way as we did in the previous exercise involving Hannah's portrait.

[A] The primary colours (red, yellow, blue) will provide us with all the hues that we need. The chart features an example of basic combinations.

[1] On the dried-out paper, we will draw the three objects in detail and paint the background with plenty of water and very diluted grey tones, insinuating the shadows from the box and the blotting paper. Using a clean and wet fine brush, thin the grey outlines of these shadows so that they appear in soft focus. We will leave the white of the paper for the areas of light, and with a drier fine brush, paint some stains from the table.

[2] With a brush that is less wet than that used in the previous step, we will begin to work on the area of the box that has the most shadow with a diluted soft grey that we will intensify later via further layers. With the fine brush, we will work in detail on the mixture of colours that we can see in this part of the original box.

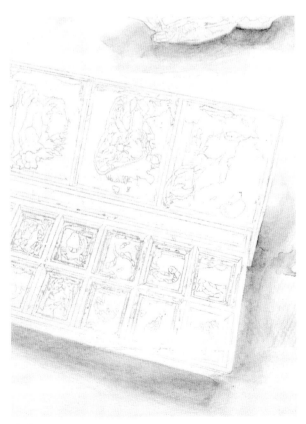

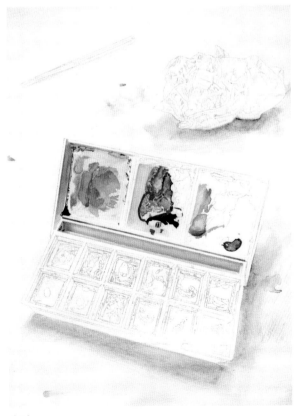

[1] [2]

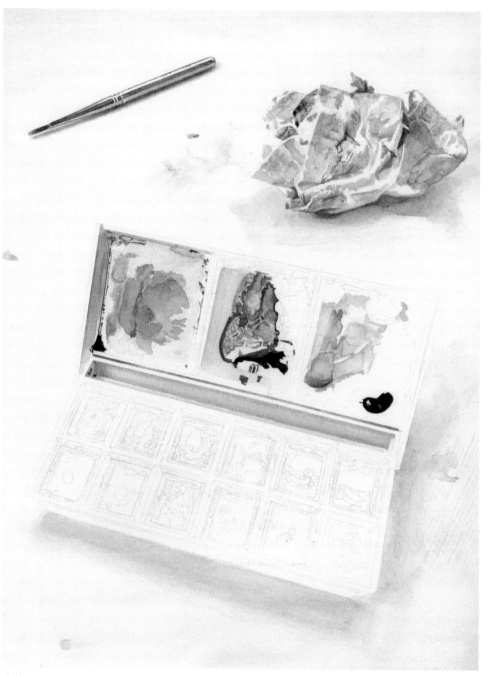

[3]

The three objects on the table—the metal part of the brush, the polished plastic of the box and the rough texture of the blotting paper—behave differently when the light illuminates them.

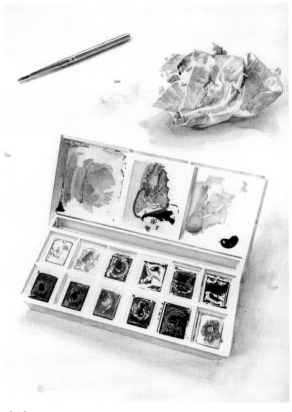

[4]

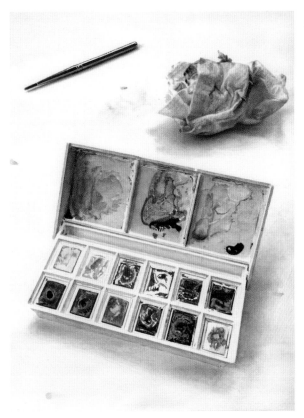

[5]

[3] Before continuing with the box, gently paint the dark areas of the blotting paper and the metal handle of the brush.

We must remember that what we are working on is light and shadow. The three objects on the table behave differently when the light falls on them. We will leave the white of the paper for the shine from the metal part of the brush and for the points of light on the blotting paper.

[4] In this step, we will focus on the pans of colour in the box. Using a wet fine brush, first of all paint the midtones of the pans, leaving the white areas on the paper for the points of light. Next we intensify the darkest parts with the drier brush and then emphasize the midtones, unifying dark with light.

[5] We then strengthen the shadows and dark areas of the three objects. The handle of the brush has to stand out through contrast, while the bristles should be smooth and delicate.

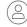

Other artists
Sylvia Plimack Mangold _ (American, born 1938) *Exact Ruler II* (1974; acrylic on canvas) is a highly detailed painting of a ruler on a wooden floor.

[B]

[C]

[B] Blotting paper has a rich texture; we must be aware of its blues here, which are saturated in the areas of shade and bright in the lit areas. With a wet brush, we will apply a transparent layer of grey on the colours of the box lid to produce a sense of shadow.

[C] We will next patiently produce the contours of the pans, observing the light and shadow. Finally, we will intensify the shadows on the table.

[Final step] We will use the dry brush to soften the tones of all the watercolour to create a feeling of naturalness. A 5H pencil can help us to define some of the box's contours.

We always need to have clean water on hand. The cleanliness of the water is so important that some people recommend using distilled water to preserve the paper better.

Other artists
Cornelis Norbertus Gijsbrechts _
(Flemish, ca. 1630 - ca. 1675)
Gijsbrechts was a Flemish painter who specialized in the trompe l'oeil technique. He painted his working tools in *Trompe l'oeil with Studio Wall and Vanitas Still Life* (1668).

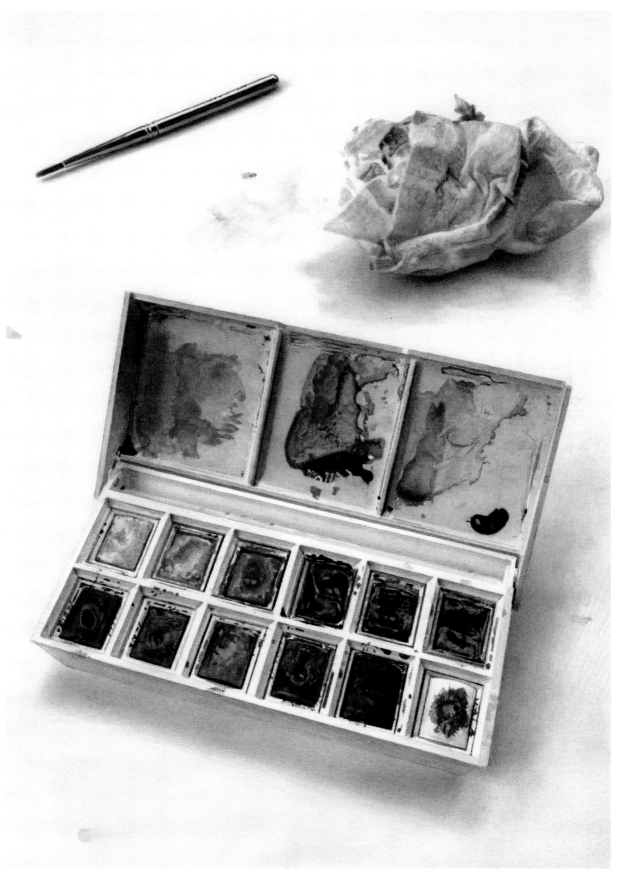

[Box of watercolours]

Water
jar

The watercolour technique involves painting with semitransparent layers called washes. We always apply light before dark, with dark tones achieved through applying several washes on top of one another. It is necessary to save the white of the paper for the points of light. When we are working with watercolour, we can make corrections by adding or removing water.

Wet watercolour

We work on wet paper. Spread the desired colour on the brush and apply gentle strokes in a horizontal direction so that the colour runs and forms a gradation. When the first layer is dry, we can apply other, different or similar layers.

Dry watercolour

We apply the colour on dry paper. The brush will be holding very little water. This technique is used for details and to create textures. The paint is easier to apply than in the case of wet watercolour, but it is more difficult to erase if we make a mistake.

Before making a grid on the paper that we will use for our drawing, we must first make one for the printed photograph of the jar that will serve as a reference point. In this case, the grid measurements will be the same on the printout and on the drawing paper [A-B].

On my work table that looks onto the garden, there are two jars of water: one for washing brushes and the other for diluting the watercolour. The second is the subject that I have chosen for the next exercise.

[A]

THE PROCESS

[A - B] To draw using the grid method, we print a 25.5 x 19 cm image of the jar and mark out 1 cm spaces. We'll need these marks to create a grid with a ruler. We apply the same pattern on the paper on which we will draw. You can number each grid square of the reference image and the paper. If you want to double the size, we will make 1 cm squares on the printed image and 2 cm ones on the watercolour paper. The important thing is that everything is kept to scale.

[1] Before plotting the horizontal and vertical lines for the grid, when it comes to making any decisions, it is important to correctly calculate the number of squares that we want on the paper. The greater the density of the grid, the more detail we can achieve when drawing the jar that we will paint in watercolour.

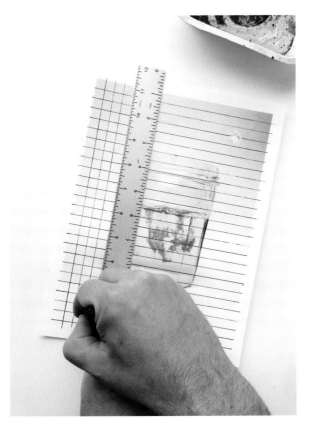

[B]

[1]

68

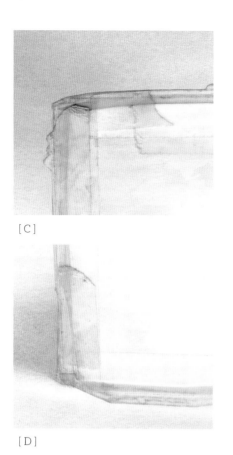

[C]

[D]

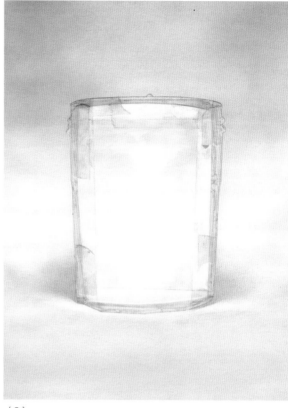

[2]

Once we remove the tape or masking fluid that we used to prevent the paint from spreading, the outlines will be very sharp. We will soften them with a fine brush and water.

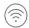

Some tips
Photoshop offers multiple tools that can help us to edit the nuances of the image that we decided to paint—for example, brightness, contrast and framing.

[C - D] It is advisable to protect the inside of the jar in the image from paint by using masking fluid, but if we don't have any to hand, we can use adhesive tape instead.

[C - D - 2] I am using adhesive tape, but if you use masking fluid, make sure that you let it dry properly. Using plenty of water and a large brush, paint the gradation of the background via the method described in the exercise on water drops that follows this one.

Wet the flat brush in diluted grey and make a brushstroke on the lower part of the paper. We then dilute the dark grey by adding water and produce another parallel brushstroke above the first one, which we will brush up against even as it is wet.

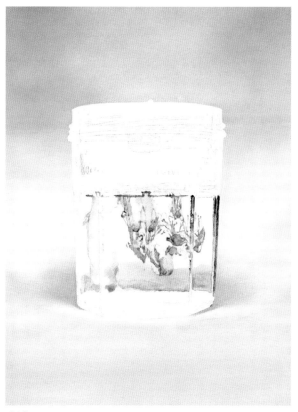

[3]

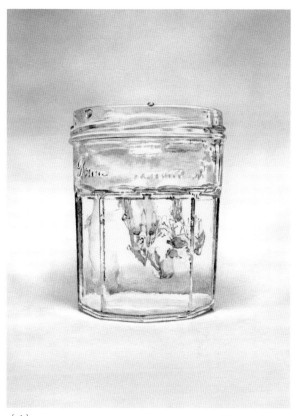

[4]

We will repeat the same steps until we have created a gradation that goes from dark to light and from bottom to top. We dry the clean brush and go over the surface with it so that the blending is natural. Once everything is dry, we remove the tape or masking fluid.

[3] We will remove the tape or masking fluid with our fingers and then, using a fine brush and a greenish blue, paint the detail of the watercolour spreading in the water; we will start with the softer midtones. We paint the diluted watercolour with more diluted watercolour. We will start with some of the grey from the jar.

[4] Next we will identify the lights and darks of the jar in relation to the reflections from the glass: flashes of white, some black spots and several greys contaminated with the greenish blue of the watercolour. Observation is our most important tool. Using a dry fine brush, we produce all these tones from the jar, leaving the white of the paper for reflected light.

When working on the background, it is advisable to protect the inside of the jar in the image from paint by using masking fluid, but if we don't have any to hand, we can use adhesive tape or masking tape instead.

[E]

If our table is well organized —I confess mine is not always—, we will be able to work more effectively and avoid accidents such as spilling the jar for dirty water over the original.

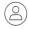

Other artists
Peter Dreher _
(German, born 1932)
In 1974, the German Peter Dreher began to regularly produce oil paintings in which he depicted an empty glass on a table and in its natural size. He paints at least fifty pictures of the same glass each year. The pieces contain subtle changes in light and position.

[E] The glass is transparent, though it is a little darker than the lit area of the background. With a wet brush and a very diluted grey, we apply a wash to the whole jar, leaving the points of light untouched.

[Final step] It is essential to have blotting paper in our other hand to reduce any excess water. Once everything is dry, we will soften the tones with a fine brush.

If a fair proportion of the watercolour has grey tones, we can smooth the gradation with a 5H pencil, applying very little pressure as we do so. This has to be done very subtly and only in very specific parts of the area that we want to fine tune. We also use this technique to define outlines. If the watercolour is coloured, this method is less advisable, though it can also be done.

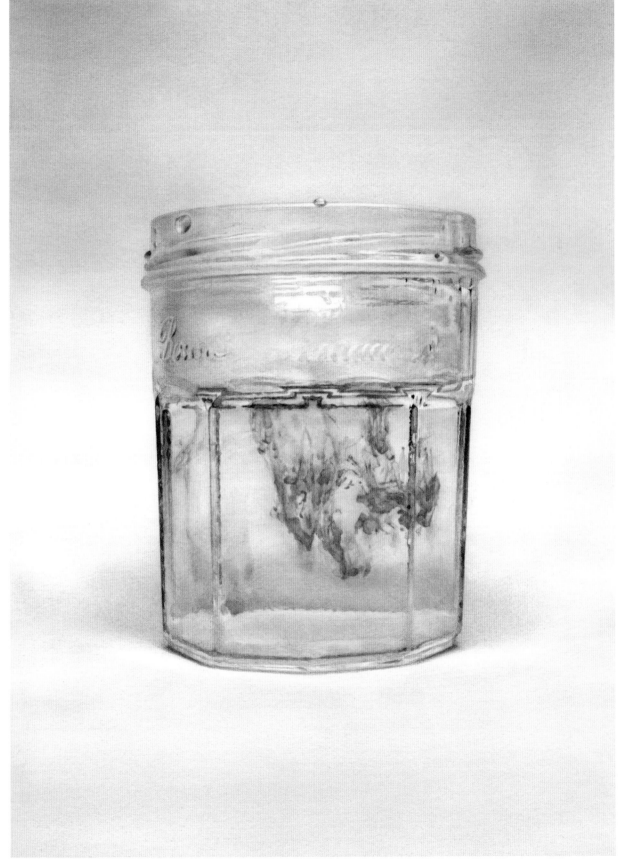

[Water jar]

A drop of water

When we wet our brush in the water jar, it is advisable to remove excess water with blotting paper or with the edge of the container so that water does not accumulate at the tip of the brush and form a drop that can fall onto the paper. This is something that happens to me a lot. We will paint a drop that just fell on my work table.

Watercolour is one of the best techniques for depicting water. If we dilute colours with water, we can obtain transparencies and intensities suitable for painting the drop that has just fallen on the work table.

The first examples of watercolour are the famous cave paintings of animals. They come from the Palaeolithic period, 31,000 years ago [A]. They were made with water and pigments.

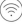

Some tips

We need to use another sheet of watercolour paper of the same type to check that the tape that we want to use to protect areas from paint does not tear paper.

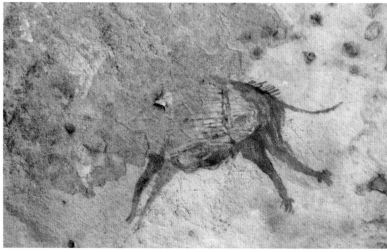

[A] Prehistoric cave painting in Bhimbetka, India.

When it is used in hyperrealism, watercolour is a technique that requires accuracy and thoroughness, and it does not give much leeway for subsequent corrections. As a result, we have to do lots of practice exercises, as it takes practice to achieve proficiency.

THE PROCESS

[1] Once we have prepared our paper and let it dry, we draw the water drop in freehand, producing guidelines that will help us to maintain the proportions.

[2] It will be very helpful if we do a quick sketch on a separate sheet of paper to mark out and establish the lights and darks before the drop evaporates.

[1]

[2]

To preserve the whiteness of the paper, it is important to make a protected area around our drop before applying the background gradation.

[3]

[4]

[2 - 3] We will attach and later on remove tape at the head of the drop, so that the lines are marked out through the tape. We stick it on a cutting board and use a scalpel to go over the line marked out.

The result is a protective area that we attach once more to the paper, making it align with the drawing of the drop.

[4 - 5] For the gradation of the background (the light comes from above and from the right, and the shadow is lower down), in a dish we prepare a greenish grey with plenty of water. Wet the flat brush in the diluted grey and make a brushstroke on the lower part of the paper. We then dilute the grey in the dish by adding water and produce another, parallel brushstroke above the first one, which we will brush up against even as it is wet. We will repeat the same steps until we have created a gradation that goes from dark to light and from bottom to top.

[6] We dry the clean brush and go over the surface so that the blending is natural. Once everything is dry, we remove the tape.

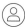

Other artists
Ken Solomon _
(American, born 1971)
Ken Solomon is a contemporary artist who likes to work with wet paper. He lives and works in Brooklyn. He captures image searches from Google and other popular digital platforms using watercolours in great, sometimes hyperrealist, detail.

[5]

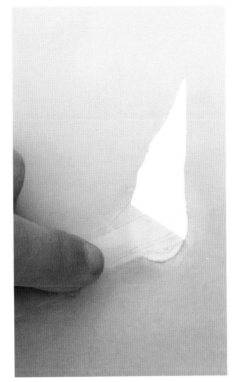

[6]

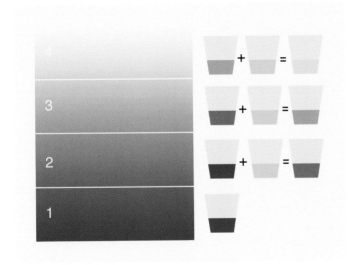

It is necessary to experiment and make mistakes as many times as necessary. Through doing so, we have more control when we paint on paper.

[A]

[A] Before starting to paint the gradation, it is advisable to prepare all the combinations that I present in the diagram, which requires five glasses: (1) The first glass features a more intense grey; we will use it for the strip at the bottom of the paper. (2) The second glass contains the grey of the first glass diluted with water. (3) The third glass shows the second grey diluted with water. (4) And a fourth glass features the third grey diluted with water, which produces a very diluted grey. Separately, we will have the large fifth glass of water and blotting paper to clean and drain the brush between steps. The process that I describe in steps 4, 5 and 6 on the previous page has to be a swift one.

[7]

[8]

The painter Carlos de Haes (Belgian, 1829 - 1898) recommended to his disciples that they squint their eyes to observe pictures, as by squinting the details are hidden and it becomes possible to appreciate all the parts of the piece at the same time.

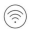

Some tips
To darken a colour, it is preferable not to add black to it, as this will change it. It is best to use a colour that follows the order of the colour wheel.

[7] When the background is dry, with the same very diluted grey, paint the trail left by the movement of the drop in a very subtle tone and with a certain volume. We will use the dry brush to produce the shadow tones that surround the head of the drop.

[8] We will now work on the drop in more detail. It is important to understand the reflection of light on water: there is a mirror effect that reflects the windows with three white lines that contrast with the dark area, and the light is reflected on the table because of the transparency of the liquid. We will use water to blend the line left by our protective area.

[Final step] Using our drier brush, we will soften the gradation from shadow to light so that the tones are natural.

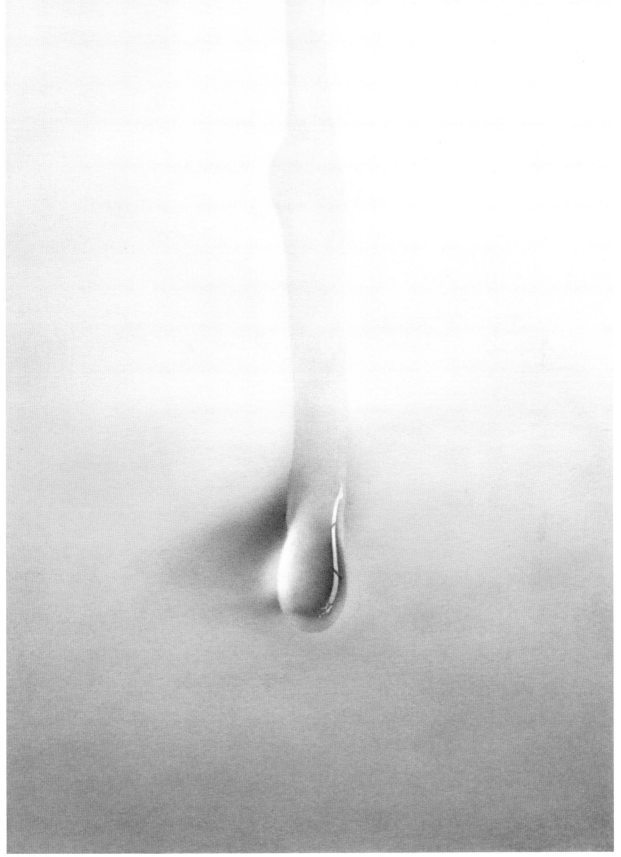

[A drop of water]

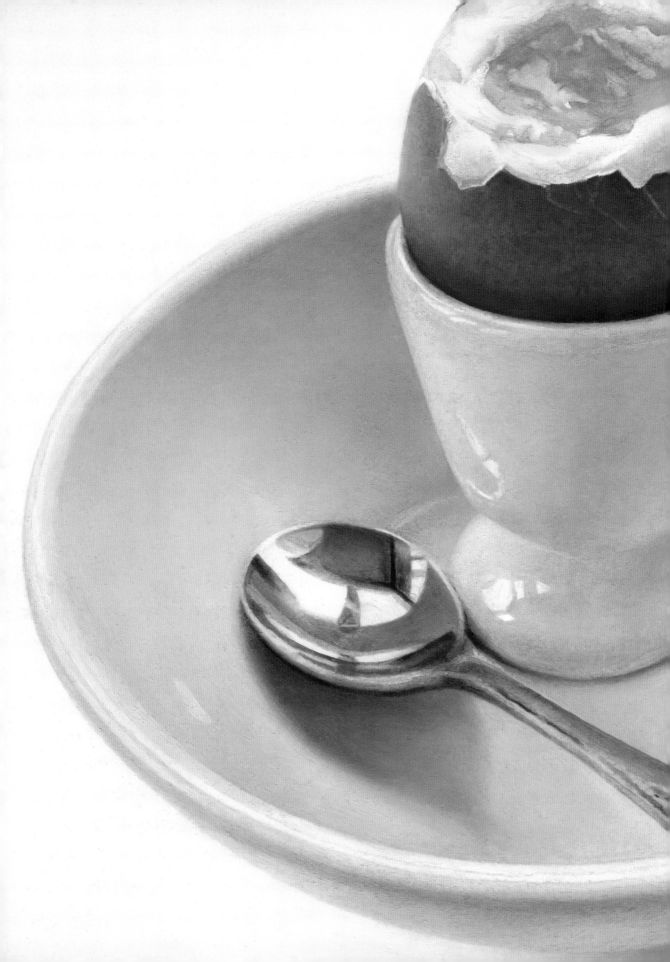

4

AFTERNOON

Oil

Now all that remains of the fog is a wet garden and water droplets on the windows. It's time to eat, and so I start to make some eggs that we bought at the farmer's market that's held on Wednesdays. They say that they sell eggs from happy hens.

Oil paint is a mixture of pigments and an oil-based binder, which is usually derived from plants. Oils are ideal for obtaining hyperrealist results. I invite you to try them through the next three exercises. ■

Materials

The materials that I am going to suggest are basically the ones that I normally use. If you go to an art store, you will see that there are many more options that come in a range of prices.

Brushes
It is very important to choose your brushes well. I usually use synthetic brushes, which have very soft and fine bristles; brushes with bristles made from natural hair are a little harder. We will need flat and round brushes.

Paint
Although paints that only require one layer are more expensive, it is best to use these instead of having to apply two or three layers to obtain the same intensity. I would opt for a mid-to-high-quality option such as Mussini, Norma, Winsor & Newton or Williamsburg. You should buy a large tube of white, as it is often used the most.

Turpentine
Make sure that you purchase a high-quality version of this. We will use it to dilute the oils and to clean our brushes. To prevent it from deteriorating, it is advisable to keep it in a dark place. Nowadays, art shops sell solvents with very little odour, and even odourless options.

Paper
It is important for us to use paper that is thick enough to not curl when we prepare it with gesso. Since we are painting on a small scale (25.5 x 19 cm), we can use **Strathmore®, 500 series, Bristol, 4 ply, plate, hot press**. For work on a larger scale, you can use high-quality cardboard, wood or canvas.

> The quality of a pigment is not related to its level of opacity but to the intensity of the colour and light resistance. Some of the best oil pigments are semitransparent.

Materials and instruments:

> Cutting board	> Flat brush	> Pencil extender
> Strathmore® paper	> Sandpaper	> Rubber eraser
> Cardboard	> Round brushes	> Pencil sharpener
> Oil tubes	> Turpentine	> Graduated ruler
> Acrylic gesso	> Cutter	> Blotting paper
> Adhesive tape	> Graphite pencil	> Cloth

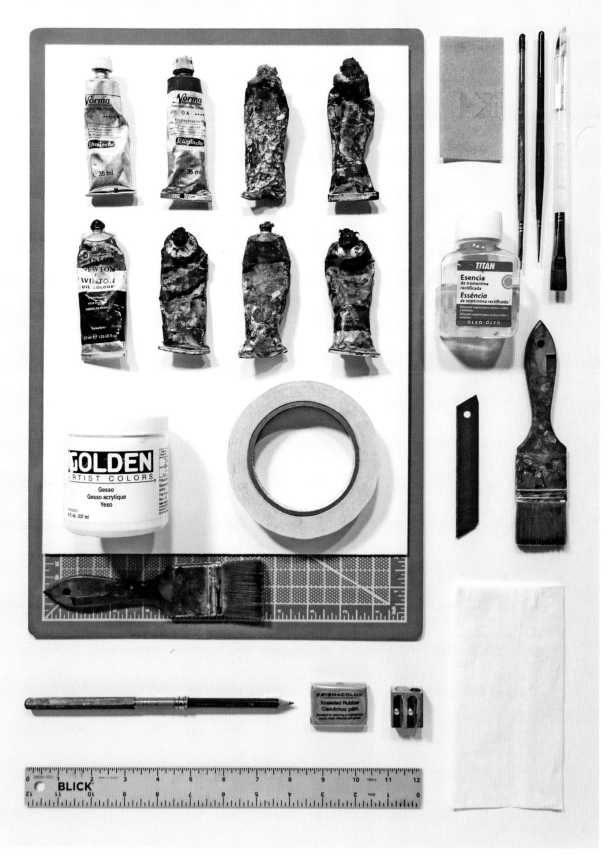

[Materials table]

Rear
window

There are three houses around ours. To the right lives Wilma, a ninety-seven-year-old and probably the oldest resident of the neighbourhood. She likes to feed the deer, which visit her at the end of the day. Recently, a middle-aged couple with two children moved into the house on our left. And from the kitchen window, you can see the house belonging to my friend Tony and his great family. We will use oils to paint the wet glass, with Tony's house appearing in the background.

For centuries, painting was largely to be found in the altarpieces and frescoes of churches, palaces and other buildings, but in the Renaissance it moved over to boards or canvases and became autonomous. The shift from walls to these is important because it meant that works could be transported and exchanged with ease. Stemming from a movable format was the idea, developed by the Italian architect Leon Battista Alberti in his treatise *De pictura* (1436), of the work as a window in which an image is depicted through a system of visual and spatial order.

Leon Battista Alberti (Italian, 1404 - 1472) conceived of the canvas as a window by introducing a device called a "velo," which he placed between the artist and the model. It consisted of a transparent fabric stretched on a frame and divided with threads that formed equal squares. This grid made it possible to locate all of the contours with precision and then transfer them to paper or wood.

Some tips

If we are working without natural light and producing hyperrealism, it is very important to have the appropriate light conditions in the form of a good light installation or a lamp designed for this purpose.

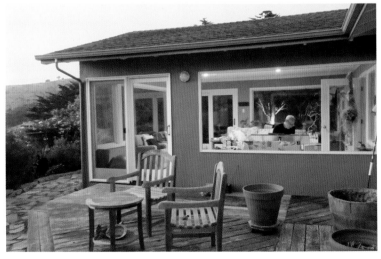

[I have spent long stretches working in the studio by the rear window]

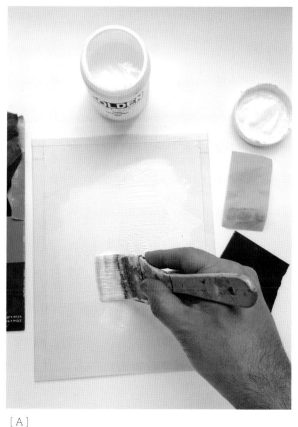

[A]

[B]

THE PROCESS

[A - B] We will protect the margins of the drawing with adhesive tape and prepare the paper with three layers of gesso that we will polish with a fine sandpaper that leaves the surface perfectly smooth.

[1] Then we produce the drawing on the paper and subsequently move on to the colouring phase.

Another option for doing outlines without the need for a pencil is to directly draw with a brush and diluted oil. Velázquez did not do an initial drawing; he would trace the general features directly with a brush.

[1]

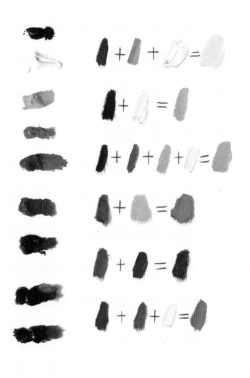

[2]

[3]

[2 - 3] Once we have prepared the colours, we will place each colour in the appropriate place on the house, painting with a lot of paint and with swift movements. In the palette I have: *French ultramarine, Winsor green, raw umber, English red, quinacridone red, cadmium red pale, cadmium lemon, titanium white* and *ivory black.*

[3] With just a little turpentine, we will mix *French ultramarine, Winsor green* and a fair amount of white, and we will paint the sky, producing a homogeneous result. Next, we paint the house with swift brushstrokes and the right colours.

[4] We will use a large and dry flat brush to go over the area that we have just

If we follow the "thick over thin" rule, we will avoid the development of cracks in the paint. We use turpentine to dilute the first (thin) layers, but we will progressively do this less and less for the subsequent layers, until we are using the paint as it comes out of the tube (thick).

Some tips

If we make a mistake when painting and the paint is still fresh, we must avoid covering the error with more oil; it is better to remove the oil from this area and repaint.

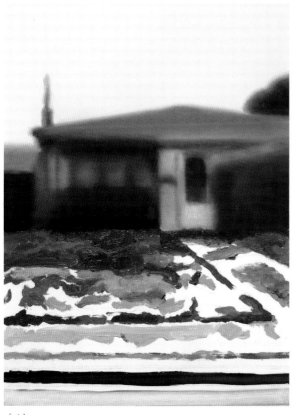

[4]

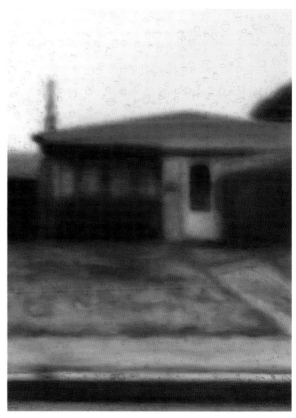

[5]

painted while it is still wet and soften the paint of the house by eliminating traces of brushstrokes to achieve the out-of-focus effect that we're aiming for. Later, the house will appear in the background.

[4 - 5] We continuously clean the brush with a cloth so that we don't get our surface dirty. We then repeat the same painting process with the garden, preparing the colours in the palette by mixing tones tailored to the real subject or to the photo.

To achieve an out-of-focus effect, we will use a large flat brush, which we will continually clean with a cloth so as not to contaminate our surface.

Once we have the shades that we're looking for, we begin to apply the paint in the right areas. In order to avoid soiling the colours during the process, it is important to constantly clean the brush with a cloth. Before we begin the next step, we let the paint for the out-of-focus exterior dry thoroughly. Two or three days should be enough time.

Other artists
Gerhard Richter_
(German, born 1932)
This painter fuses painting and photography in his works, challenging the usual debate between real and abstract.

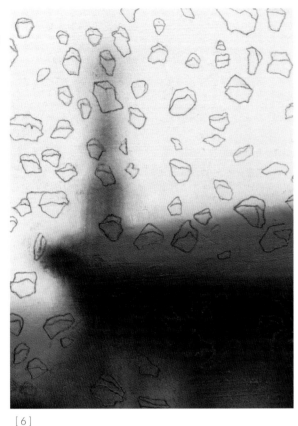

[6]

[7]

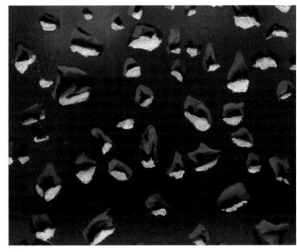

[C]

[5 - 6] **We transfer the drops** onto the painted background of the house and garden. To do this, we will follow the steps for the tracing system that I described in the chapter on self-portraits (see page 17).

[7] **Working from top to bottom, we paint the drops,** which differ from one another according to the reflection of light. Unlike in watercolour, we add white to produce shine when we are using oils. The drops toward the top reflect the sky. And so we have black and grey for the dark parts, greenish blue for the sky and white for the shine. We are now using the paint directly from the tube.

[Final step] **The drops at the bottom reflect the garden:** we need black and green for the dark parts, and light greens and white for the shine.

At the end, when the drops are dry, we reinforce these points of light with white [C].

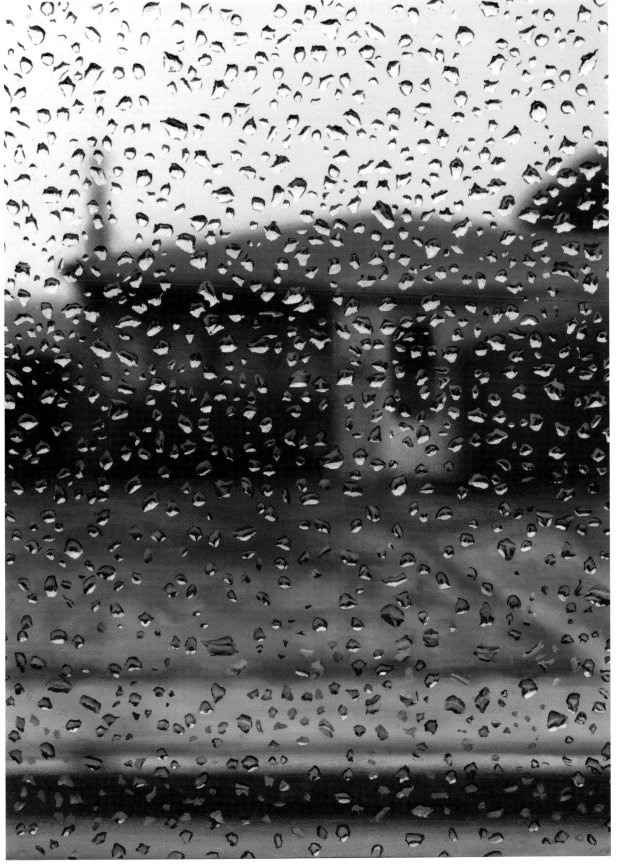

[Rear window]

Culinary
still
life

When I visit my family in Barcelona, I realize the time difference between there and America when it comes to eating: people eat a big, late lunch and have much smaller dinners. In contrast, in the United States people eat fast, improvised lunches, but they have big dinners. The truth is that I've become used to new habits. If I have an egg like the one that we will make in a moment and a typically Californian fruit smoothie, I'll be happy. But don't leave out the coffee and a bit of chocolate. Celeste has made herself a peanut-butter sandwich.

You need five minutes to boil an egg:

1. Heat water in a saucepan. We need enough to be able to cover the egg.

2. . When the water reaches boiling point, use a spoon to lower the egg into the pan.

3. We leave the egg in the boiling water for five minutes—no more, no less.

4. Take the pan to the sink, pour out the hot water and run the egg under cold water.

5. We gently tap one end of the egg with a teaspoon, and then we peel the shell off with care.

While I finish off the egg, let's start on an oil culinary still life that we will call *Egg cup with boiled egg and spoon on a plate.*

Hyperrealism reflects on how technology has changed the way we perceive objective reality.

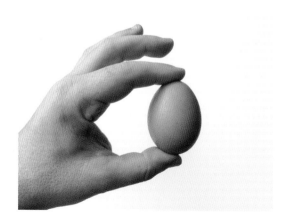

Some tips
In order to avoid noticeable brushstrokes, we are can "comb over" the wet surface with a large dry, clean and soft flat brush, applying pressure very sparingly and in the same direction (from top to bottom).

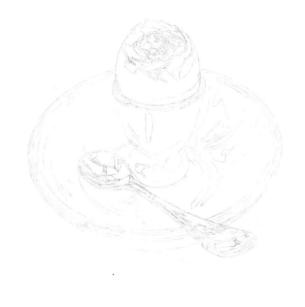

[1]

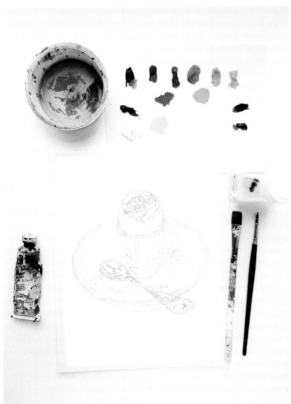

[2]

THE PROCESS

We prepare the paper (Strathmore®, 500 series, Bristol, 4 ply, plate, hot press) in the same way as we did in the previous exercise, protecting the margins of the drawing with adhesive tape. We cover the paper with three layers of gesso, which we polish with a fine sandpaper to leave a perfectly smooth surface.

[1] We will now transfer our drawing to the paper using the previously described tracing system. It is a good idea to use gentle lines when making the reference drawing. This will ensure that when the oils are applied, they will properly cover the lines to prevent them from being visible.

[2] In the palette we have: *Winsor green, raw umber, quinacridone red, English red, cadmium red pale, French ultramarine, cadmium yellow, cadmium lemon, ivory black* and *titanium white*.

If we want to save ourselves the trouble of having to clean our palette, instead of using one made from materials like wood or plastic, we can use a few disposable paper palette sheets, which are sold in pads of fifty. This is an appealing solution if we work on a table.

[3]

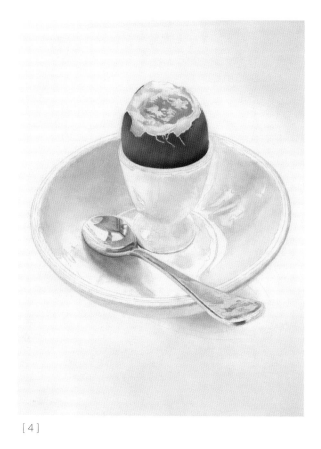

[4]

[3] When the light illuminates the three elements of our culinary still life, each of them behaves differently. For example, the metal of the spoon acts as a mirror, reflecting the windows and ceiling. We will paint the reflections white, and the rest a bluish grey contaminated by the blue of the wall of the room. We will render with the shadows of the ceramic bowl with a warm grey by mixing *titanium white* with a little *ivory black* and *raw umber*, as well as with a touch of *cadmium lemon*.

[4] Using *English red, cadmium red pale, quinacridone red* and *raw umber*, we will take our first steps toward producing the colour of the shell, taking into account the way in which light and shadow will give us the characteristic shape of the egg. We leave the lines white to suggest the cracks.

We can find still-life ideas in any activity from everyday life, or we can make a composition, deploying a certain aesthetic sensibility, of a series of objects and then paint them.

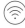

Some tips

If we look at a still-life painting through a mirror, we will discover details and errors that may have escaped the naked eye.

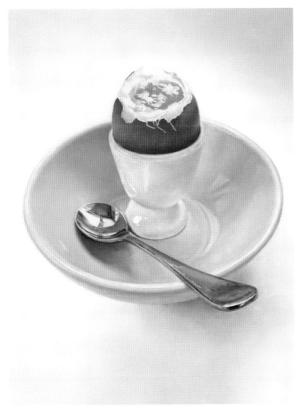

[5]

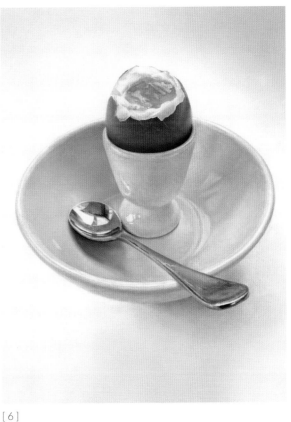

[6]

[4 - 5] Next we continue with the rest of the egg. We will do the egg white with shades of a very pale yellowy grey, and we will paint the yolk using a bright orange and yellow, with white at certain points. We will also produce the egg cup's points of light.

[5 - 6] While we let the egg and the cup dry, we will return to the spoon, noting the subtlety of its different tones.

There are lines of bluish greys, areas of an orangey grey, cool-grey parts, a contrast of black and white at the upper part of the handle and bright white from the reflected windows. After that, we focus on the yolk area.

In ancient Egypt, still lifes adorned the inside of tombs. It was believed that objects linked to food and domestic life would become real in the beyond and that the dead could use them.

Other artists
Ralph Goings _
(American, 1928 - 2016)
This painter is associated with photorealism and superrealism. I am interested in his still lifes of food and apparently humdrum objects, which he renders with technical perfection.

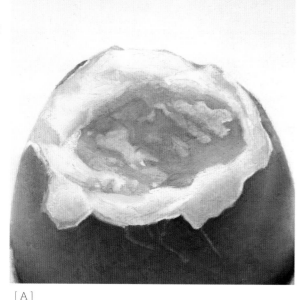

[A]

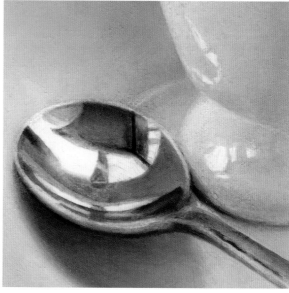

[B]

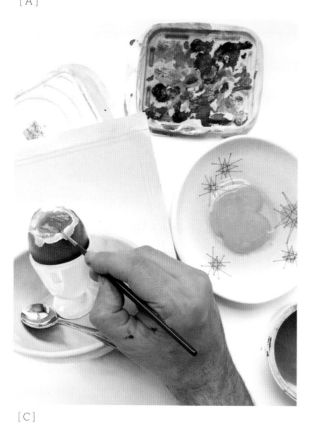

[C]

[A - B] Using just a little turpentine, paint the egg yolk, focusing on its details. We will also strengthen and soften the lights and darks of the dish and its gleaming parts and intensify the shadow produced by the spoon.

[Final step] We will first of all work on the egg cup, which has some greys and whites that are colder than those of the plate; some areas are contaminated with the warm light from the plate. We strengthen the white of the shining patches close to the spoon.

And then we paint the egg, covering the previous, now dry layer and focusing on the details of the shell, the white and the yolk and their highlights and textures until we have attained hyperrealism.

Photos do not let us precisely appreciate subjects' actual colours or the movement of light. As I have already eaten the egg and am using a photograph to paint, I have broken open another egg so that I have a reference point for the colour of egg yolk [C].

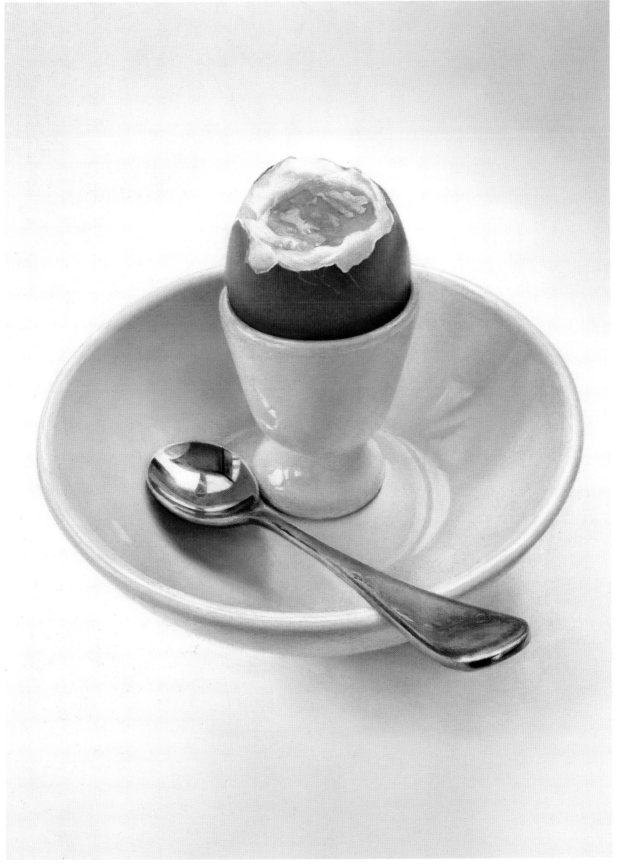

[Culinary still life]

Hawfinch

We have seen lots of different animals in Sarah's garden over the course of July [A]. During the day, it is filled with all kinds of insects, as well as with birds that feed on them. Hawks fly over the house, alternating between beating their wings and gliding, while crows, in the face of imminent danger of attacks from birds of prey, alert their congeners.

At sunset, the hummingbirds appear, feeding on the nectar of flowers, and deer also come out to eat the shrubs. In the evening, raccoons dig in the trash, and a skunk wanders around, followed by its characteristic bad smell. During dry spells, you can see coyotes looking for fruit that has fallen from the trees.

The studio has two large windows at its sides that reflect the landscape and confuse birds that do not know that their surfaces are hard and transparent. At one point this month, what may be a hawfinch had the misfortune of getting confused by the window. We're going to produce a little tribute to it by making it the subject of our oil painting.

Before starting to paint the hawfinch, we must observe its colours: the overall colour of the plumage is brown; the head is more orangey, as is the face, though it is lighter. The eyes are surrounded by an intense black border that extends toward and skirts around the beak and then goes toward the throat, which is black. All of the breast and lower parts are a dull whitish brown. The wings are completely heterogeneous in terms of colour.

Some tips

When working with oils and changing between colours, we must clean our brushes to prevent mixing between them. Place the brushes in a jar containing turpentine, shake them, and dry with a cloth.

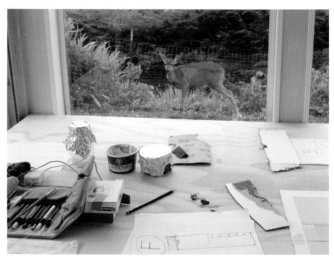

[A]

THE PROCESS

A method that artists have used for centuries is to stain surfaces with earth colours diluted with turpentine. This method not only makes starting less intimidating but also means that we have a background that is less bright than white and closest to the painting's predominant tone.

[1] We paint the background with a bluish-grey acrylic and produce a gradation from dark to light with three previously prepared tones: dark bluish grey, bluish grey with a touch of white, and bluish grey with a lot of white. We use one brush to paint the dark area and another brush for the midtone, which we will blend with the dark part.

We take a third brush and paint the lightest part, blending it with the midtone on the paper.

[2] Combining *titanium white, French ultramarine and ivory black,* we will improvise, based on our imaginations, a few clouds of the kind that we'd typically see on a rainy day. Take the dry brush and, with a bit of white—directly from the tube—rub it on the dry acrylic to produce the lit areas of the clouds. Use blue, white and black to make a bluish grey that is a little darker than the base acrylic and work on the dark tones to achieve, along with the light tones, the volumes of the cloudy sky.

[1] [2]

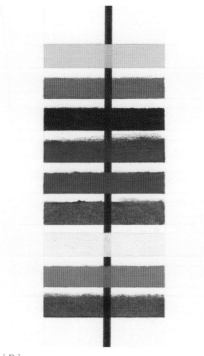

The glazing technique allows you to apply a thin, almost transparent layer of one colour over another, dry layer to modify and/or darken it. This give the painting a special effect of lightness and depth, as well as an extraordinary realism.

[B]

[B] A knowledge of the degree of colours' transparency is essential when working with oils. There are transparent colours and opaque colours that vary according to the colours that we are applying and the makes that we are using. Opaque pigments cover surfaces perfectly, while the surface can be seen through transparent ones, though these nevertheless change the hue. When we use transparent colours, the elements that we are painting appear further away, creating a sense of depth. They are ideal for shadows and backgrounds. In contrast, opaque colours make things seem closer, and they are used a lot for lights and shine. The two types can be used in the same painting.

[3] Using the tracing system described in the exercise on self-portraits (see page 17), we will transfer a drawing onto the painted sky. We then prepare the palette with the following colours: *French ultramarine, Winsor green, raw umber, English red, quinacridone red, cadmium red pale, cadmium yellow, titanium white* and *ivory black*. We paint our model by locating the whites and bluish colours of the beak and the blacks that surround it. Next, we apply the orangey and brown colours of the face, which we paint in accordance with the rhythm and direction of the feathering. We then locate the dark areas of the rest of the body.

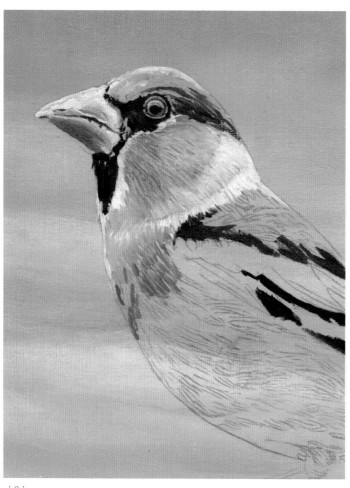

[3]

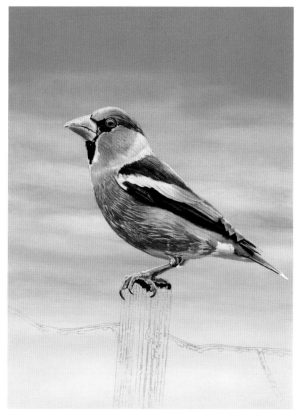

[4]

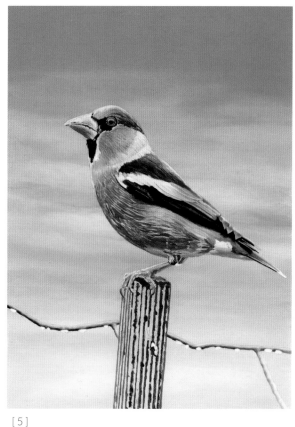

[5]

[4] In this first phase of rendering the hawfinch, the greyish blue colours of the sky that we painted earlier will be partially visible behind the oils applied to produce the hawfinch. These will help us to integrate the bird into the background more effectively. We are now painting using the glazing technique, which requires several layers to produce the desired volume and bright colours.

We achieve the volumes by working on the light and dark tones of the body and wings. We use a fine brush to produce the feathers, following their direction.

[5] Our bird is resting on a weathered wooden post. The weathering has given the material a wealth of colours and texture. Use an *ivory black* to paint the shadow left by the leg and foot resting on the post, and with *raw umber* produce the vertical shadows of the wood. We then focus on the plastic wire, which we should produce using *Winsor green* mixed with white for the part that is illuminated and with black for the shadowed part. The wire has a few water drops that indicate that it has been raining. We paint these with white straight from the tube, which we will intensify later, once the paint from this step is dry.

Transparent colours applied as glazes help us to obtain intense or bright colours. However, when we mix them with white or opaque colours, they lose their transparency and vividness.

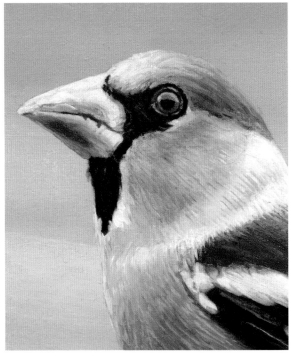

[C]

[D]

There used to be a brown pigment called "mummy brown", and it was obtained from the decomposition of mummies that were clandestinely imported into Europe from the twelfth century.

[C] We will now return to the bird's head, intensifying the blacks surrounding the beak and the whites of the beak, the neck, the top of the head and some areas of the wings. Using the glazing technique, we intensify the tones that we painted in steps 3 and 4, taking into account darks and lights: the illuminated parts of the face, neck and wing, and the shadowed areas of the breast and wing.

[D] We then begin the second phase for the wood by locating the light tones, which will provide the texture that defines the wood's feeling of volume.

We may think that a post like this is just brown, but when we are painting, we must look closely at the wealth of shades of the material and its imperfections.

[Final step] Lastly, we contrast areas of shadow and light, and we soften any details that look a bit rigid with the dry brush. We want to achieve a result that seems as natural as possible.

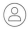

Other artists

I want to mention the works produced by many talented scientific illustrators over the centuries. At the same time as they have been required to adhere to the highest artistic values, they have been required to adhere to a set of rules, such as the correct use of three-dimensional perspective, the use of the appropriate materials and the correct application of light on the subject so that all the structures of the specimen or object are perfectly depicted. Here are some examples: **John James Audubon** and his *The Birds of America*; the watercolour *Wing of a European Roller* by **Albrecht Dürer**, or the botanical illustrations produced by **Lilian Snelling**.

[Hawfinch]

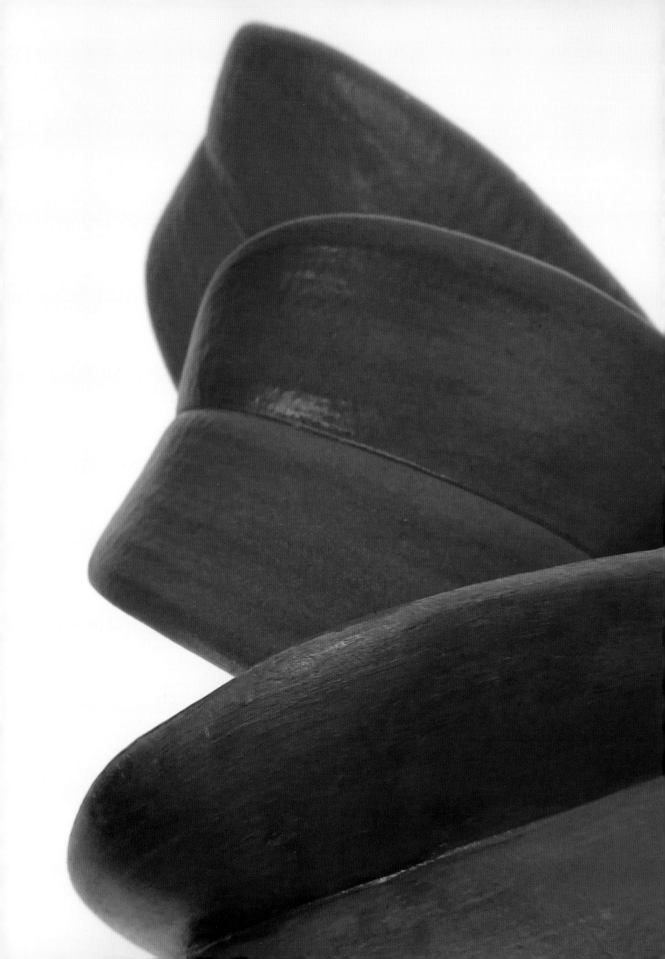

EARLY EVENING

Sculpture

Trompe l'oeil is a technique that involves pushing pictorial effects to their limits to simulate objects' real or corporeal appearance. This artistic technique, which is also known as "illusionism," emerged out of the encounter between the discovery of the laws of perspective in Italy in the fifteenth century and the paintings of the Flemish school.

Of late, trompe l'oeil has started to be used in very different areas, including creative cuisine. This is the case of the farm egg at the Villa Paramesa restaurant in Valladolid, a dessert that looks like a hard-boiled egg, when in reality its shell is made from white chocolate, the yolk from mango and the white from green tea. Fruits and plants have also been imitated to perfection for decorative purposes. Moreover, many contemporary artists use trompe l'oeil in their artistic offerings.

In this section, we will use trompe l'oeil to produce a sculpture. ■

Materials

Sculpture involves completely different processes according to whether we are working on a small scale or on a large one. In this book, I offer exercises focused on an intimate small scale, and therefore we will use materials and instruments that will not work for larger sculptures.

Clay
I normally use the Plus® or Das® brands, but there are others that have the same characteristics: modelling clay that does not need firing and that may be white, earthen or grey.

We will sculpt the clay and then paint it with the materials shown in the image.

Paint
Oils vary greatly in price depending on the quality: I usually choose a mid-to-high-quality option such as Mussini®, Norma®, Winsor & Newton® or Williamsburg®. They are made to be odourless.

We will need a medium brush for the main surfaces and a fine one for detail.

Turpentine
Purchase a medium-sized pot of distilled turpentine for diluting your oils. I use Winsor & Newton® turpentine.

Since we are looking at trompe l'oeil, I created replicas of the materials in this section following the technique that we will deploy here.
[See pp. 104 - 107]

Materials and instruments:

> Sandpaper

> White acrylic

> Round brush

> Oil tubes

> Turpentine

> Scalpel

> Clay

> Graduated ruler

[Materials table] Made following the hyperrealist sculpture technique. See the steps on pp. 104-107.

Hyper-realism in <u>3D</u>

For these sculpture exercises, we need a tube of oil, a tube of acrylic, a scalpel, sandpaper, a brush and clay. But before we use these, we will make a replica of some of these objects.

There are many brands of materials for mould making and tutorials on the Internet that can help us to use them. For this exercise, we will work with the following [B]:

Silicone mould:
This has major advantages: it is flexible, washable and very light, and removing items from it is easy.

Resin:
This is a material that provides firmness. It can be coloured, and it produces pieces that are not heavy.

[A]

Some tips
Although we have not achieved an exact copy of the original model—even if it is very similar—the fake object seems real because it is on its own, without the original by its side, and so we cannot compare them.

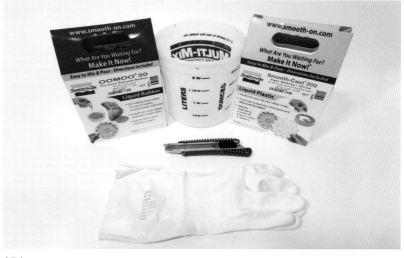

[B]

[1]

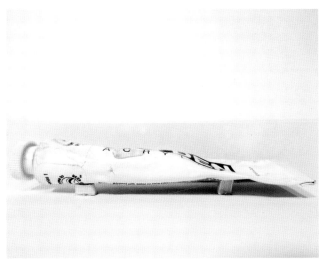

[2]

[3]

Making the mould

[1] We build a cardboard box that looks like a model of a house with no a roof. As a result, we have four chambers with walls that are joined together.

[2] With the same glue gun that we just used to make the box, we affix two very small pieces of cardboard to the bottom of the objects and to the base of the box to avoid direct contact between the objects and the box.

[3] We put one object in each chamber, with a distance of approximately one centimetre between the walls and the object.

[4-5] We mix the silicone and the catalyst in careful accordance with the instructions for the products. We wear latex gloves while we are doing this. Pour out the liquid into each of the chambers, completely covering each object. We must bear in mind that silicone dries quickly, so we will work quickly.

[5] We wait for the time period indicated in the instructions for the fluid to fully dry (this may take six or seven hours). Then we break the walls and remove the silicone blocks that the objects are contained inside. Upon removing the block of silicone from the bottom surface, we will see that there are two holes. We will need these later.

[6-7] With our knife, we cut in a snake shape and carefully remove the item from the inside, doing so in a way that leaves a space that's in the shape of the object. We now have silicone moulds with two holes in them, and so we're ready for the next step. But before that, we will place some elastic bands around the surface of the silicone to prevent the liquid resin that we will now insert from escaping.

[4]

[5]

[6]

[7]

[8]

[8] We will mix the resin with the catalyst in accordance with the product instructions and insert the liquid through one of the holes (as indicated in the diagram) until it just starts to come out of the other. This is a process that we do slowly and carefully. If we put too much fluid in, when it is dry we will have to spend more time cleaning things up.

[9 - 1 0] After an hour, we carefully remove the dry and hard resin from the silicone mould through the incision we made earlier with our knife. We will use that same knife to cut and smooth the small excesses from the process. The result is an exact replica of the original. We now have resin objects made using a silicone mould.

[1 1] We will now paint the replica of the tube of oil paint and the scalpel with a silver spray. Before we do, using adhesive tape, protect the label area of the tube to keep it white. When the silver of the tube is dry, use your fingers to make it a bit messy using dirtyish colours, therefore making it look like it has been used.

[1 2] We will use a green spray for the handle of the brush and a silver one to mimic the metal that keeps the bristles in place. After that, we will paint the bristles brown.

[9]

[11]

[12]

[10]

[13]

[14]

[1 3] We will cut a rectangular piece of yellow card. Paint its surface with a flat brush; we will use *raw umber* oil paint that has been fairly diluted with turpentine. I once accidentally discovered that, when oil paint comes into contact with paper, it leaves a few tiny specks that resemble the texture of sandpaper.

[1 4] Finally, with a marker and on paper adhesive tape, we draw the brand of the acrylic and glue it on the tube.

[Final step] We take a photo, like the one on page 103, of the set of counterfeit objects: the tube of oil paint, the tube of acrylic, the scalpel, the sandpaper and the brush [A].

Sculpting a <u>leaf</u>

One of our tasks in the house is to take care of the plants. We have clear instructions, but unforeseen things have happened, as was the case with the orchid by my table. Sarah recommended we spray the leaves with water to mimic their natural habitat and create the right humidity level. But one leaf dried out! [A]. Without it, the plant is unbalanced. And that's why I've decided to replace it with a new one, which we will make using the trompe l'oeil technique [B].

We will mould clay and use oil paint to make a leaf that looks like all the ones on the plant yet not like any one in particular. It'll be like forging a Picasso by painting one that does not exist but that has all the elements of a Picasso.

If we have leftover clay, we should save it by wrapping it in a plastic bag so that it does not dry out and so it can be used again in other exercises.

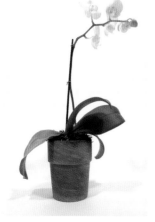

[A]

[B]

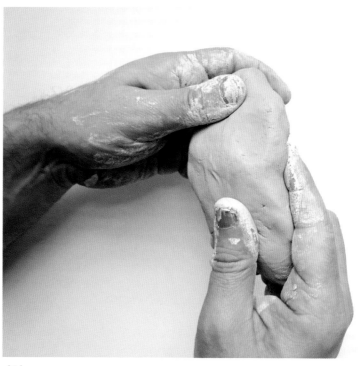

[1]

THE PROCESS

[1-2] We will use clay to make an initial version of the leaf shape, making it slightly larger so we have leeway to carve and sand with a scalpel and sandpaper until we have achieved the desired shape.

[3] The drying time will vary depending on the ambient temperature and on the thickness of the clay leaf. We need to leave twenty-four hours for the piece to completely dry.

We then carve the dry leaf while observing the original leaves. First, we work with the scalpel, using great care to avoid cutting or breaking the leaf, and finally with the sandpaper we refine the leaf, leaving some imperfections of the kind that we see occurring in nature.

If the plant were not an orchid and the leaf had very pronounced lines with some relief to them, we would be able make impressions by pressing the two sides of the original leaf against the two sides of the wet-clay leaf, which would mark the original texture in the clay. The orchid leaf is very smooth, and so this trick isn't required.

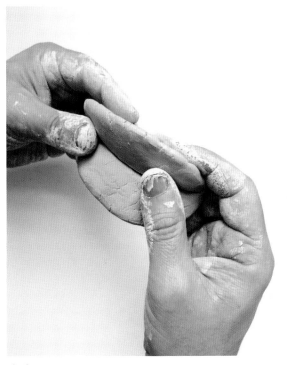

[2]

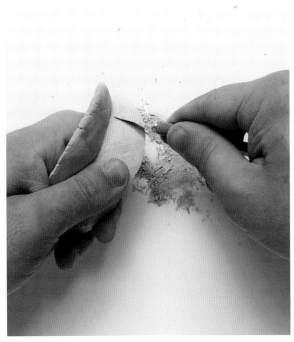

[3]

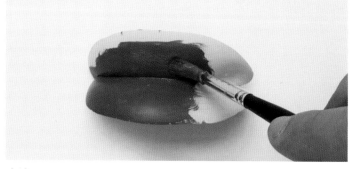

[4]

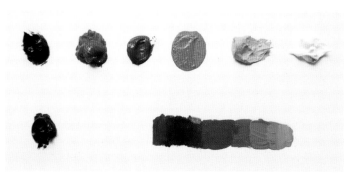

[5]

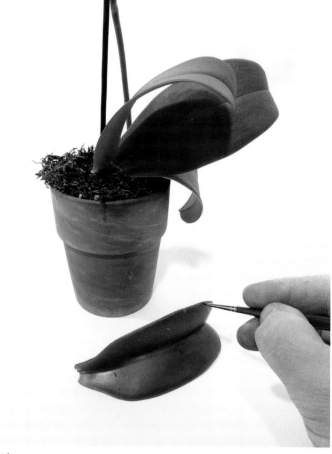

[4] **With a little water, we will mix the acrylics**—green, orange, white and a touch of black—and with the original leaf in front of us we will experiment until we achieve the right colour.

[5] **The acrylic will serve as the primer for the oil painting.** We need the following oils in our palette: *Winsor green, raw umber, quinacridone red, English red, cadmium red pale, cadmium yellow* and *titanium white.*

If we mix green, yellow and white, we will have more light; if we mix in *raw umber*, there will be less light. We will use very little turpentine to dilute the colours. We will paint the surface, replicating the tones of the original leaf.

[6 - 7] **We then focus on the detail:** breaks in the leaf, a stain, lines and so on. Finally, we use *raw umber, quinacridone red* and *English red* for the reddish detail of the edges, which we can see in the original leaves.

If we mix green, yellow and white, we will have more light; if we mix in *raw umber*, there will be less light.

[6]

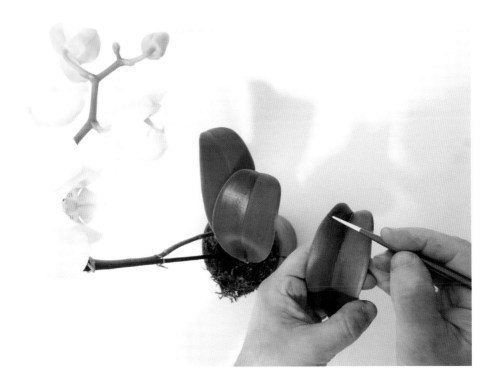

[7]

Moulding clay and painting in oils, we will make a leaf that looks like all the leaves of the plant yet like none in particular, as this will truly make it another leaf, with all its realism [C].

Some tips
When painting the surface of the leaf in oils, before working in detail you can use your fingers, with a cloth always to hand.

[C]

Other artists
David Adamo _
(American, born 1979)
In his minimalist installations, this contemporary artist immortalizes various objects with small trompe l'oeil sculptures. He reproduces everyday elements such as used erasers or broken biscuits from clay, or M&M's® from painted bronze.

112

Illusions are not just for magicians; the world of trompe-l'oeil is an interesting field that can serve as a source of further artistic expression.

[D] I followed the instructions Sarah gave me before travelling to Australia to the letter, but I couldn't stop one of the leaves drying out. Here is a somewhat sad picture of the plant.

[E] Illusions are not just for magicians; the world of trompe-l'oeil is an interesting field that can serve as a source of further artistic expression or to solve a specific problem, such as the one we have here. Sarah won't realise.

[Final step] To achieve a flawless final result, it is important to get the placement of the leaf in the flowerpot right, so that visually it is in balance with the rest of the leaves and produces a feeling of naturalness.

Other artists
Tom Friedman _
(American, born 1965)
This artist turns common objects into philosophical constructs. He explores both the qualities of objects and the experience of making art through repetition, mutation and dimension. His work stands out owing to its humour and great inventiveness. Friedman's ultrarealistic fly on an old pedestal is in my view an artistic masterpiece of trompe-l'oeil sculpture.

[D]

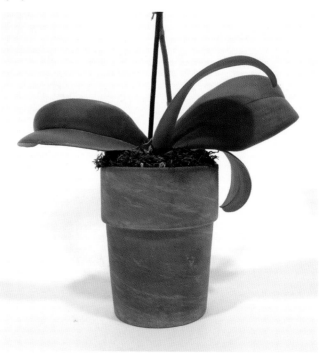

[E]

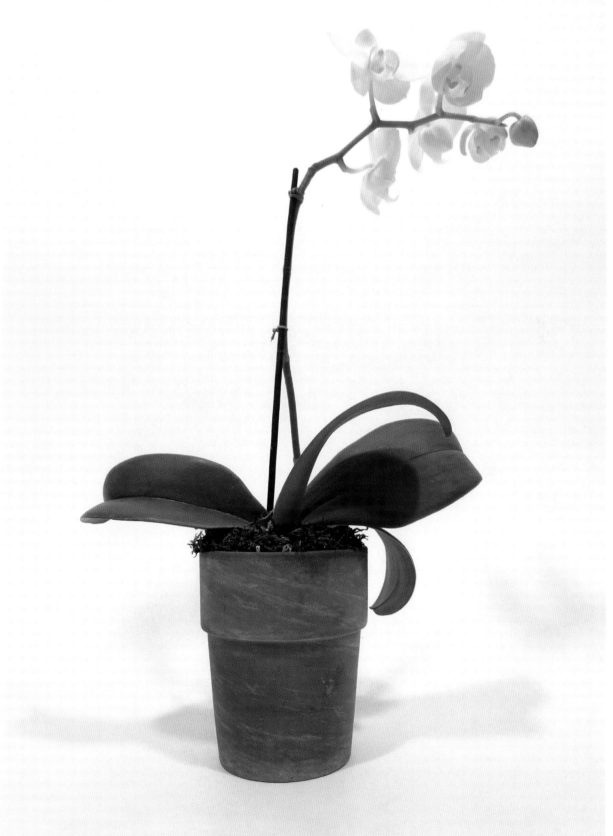

[Sculpting a leaf]

Bar
of
soap

It's six-thirty in the evening and we have two hours of natural light left before the sun sets.

I have time to do one last exercise, clear up the table and clean the brushes with washing-up liquid or with a bar of soap.

A painter's home is not the best place for bars of soap that want to take it easy. They do a lot of work and live short lives.

As a tribute—and they deserve it—we will immortalize one of them in a trompe l'oeil sculpture.

In addition to modelling clay by hand, nowadays we have many options for achieving the exact shape of an object—for example, 3D printing, silicone moulds, carved wood and bronze.

Some tips

To become familiar with the world of trompe-l'oeil and fake objects, it is important to start with simple objects and learn from mistakes and successes. We will raise the bar little by little until we achieve more complex results.

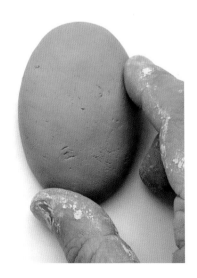

[1]

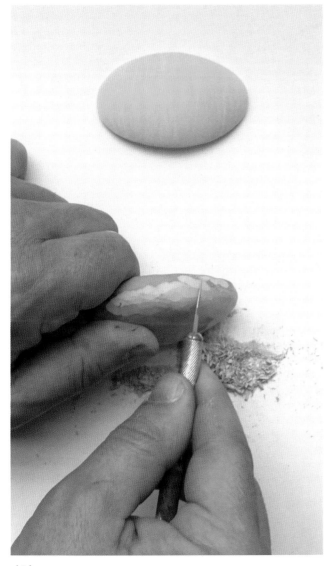

[2]

THE PROCESS

[1] Gather the desired amount of clay and do an initial version of the shape of the soap, making it a little larger so we have leeway when it's time to carve with a scalpel and polish with sandpaper.

[2 - 3] Although the object is small, we must estimate twenty-four hours as the time required for the clay to totally dry. We then sculpt the soap while paying close attention to the original. We start by using the scalpel, being very carefully to avoid cutting ourselves, and we finish up with sandpaper to polish the surface of the clay soap.

[3] We will check the thickness and shape of our bar before moving on to the painting stage.

[3]

It is important to fully polish the clay and allow it to dry before applying the paint, so that it adheres well and so there are no imperfections.

[4]

[4] We apply three coats of white gesso as a primer before we begin to apply the oils. We will polish the last layer of gesso with a fine sandpaper.

[5 - 6] We have the following oils in the palette: *quinacridone red, titanium white, cadmium lemon* and *cadmium red pale*. With a generous amount of white in the palette, we will add the rest of the colours and mix them little by little to get the right tone. We need very little turpentine to mix the colours.

The original has a few light stripes and others that are darker. Paint the surface of the clay, imitating the darker pink tone.

Gesso is an ideal primer, because it allows a good level of absorption that helps the paint adhere to the mud without the paint drying out.

[5]

[6]

[7] Working over the still wet pink and with a very fine brush, apply a more pinkish colour with more white for the light lines, observing at all times the forms of these lines in the original soap.

[Final step] Finally, we work on the detail: the cracks, imperfections and stains that soap typically has.

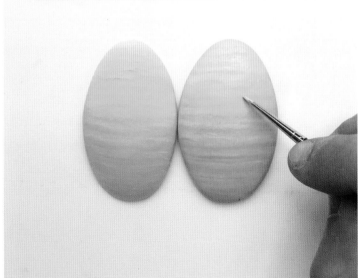

Other artists
Roula Partheniou _
(Canadian, born 1977)
Roula Partheniou is a contemporary artist whom I recommend. Using trompe l'oeil, optical illusions or visual similes, she creates an alternative logic from common materials.

[7]

[A]

If you want to use an artisanal bar of soap to clean brushes, I recommend ones that are made using fat. Rub the brush in circles directly on the bar. Use your fingers to press down on the base of the bristles so traces of paint that will make the brush swell up in the future do not accumulate [A].

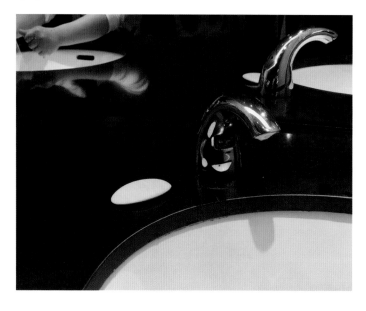

Some tips
The World Health Organization tells us that it takes between forty and sixty seconds to wash your hands properly. We need to rub our palms, backs of hands and fingertips.

Bar of soap for a sink at MoMA
The fake clay soap made in this exercise was exhibited in a bathroom at MoMA in New York on 29 March 2018.

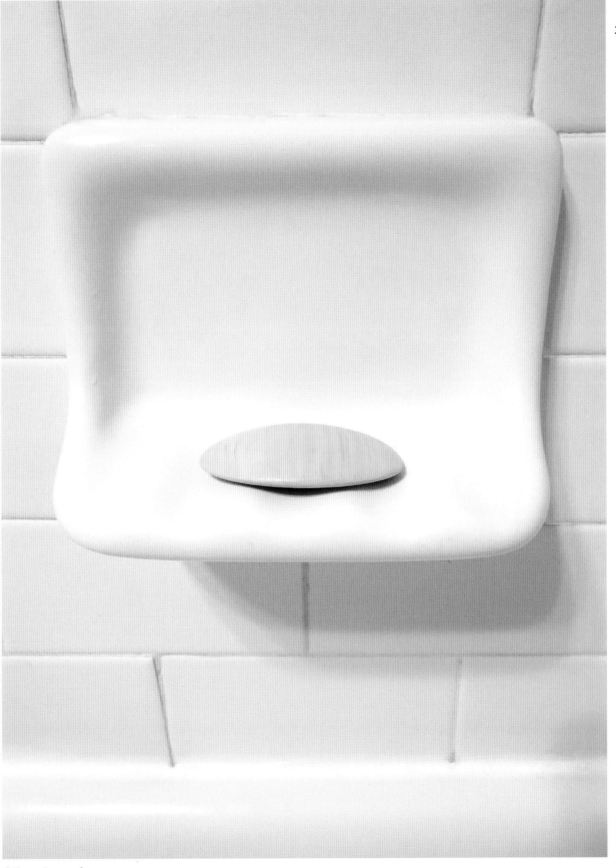

[Bar of soap]

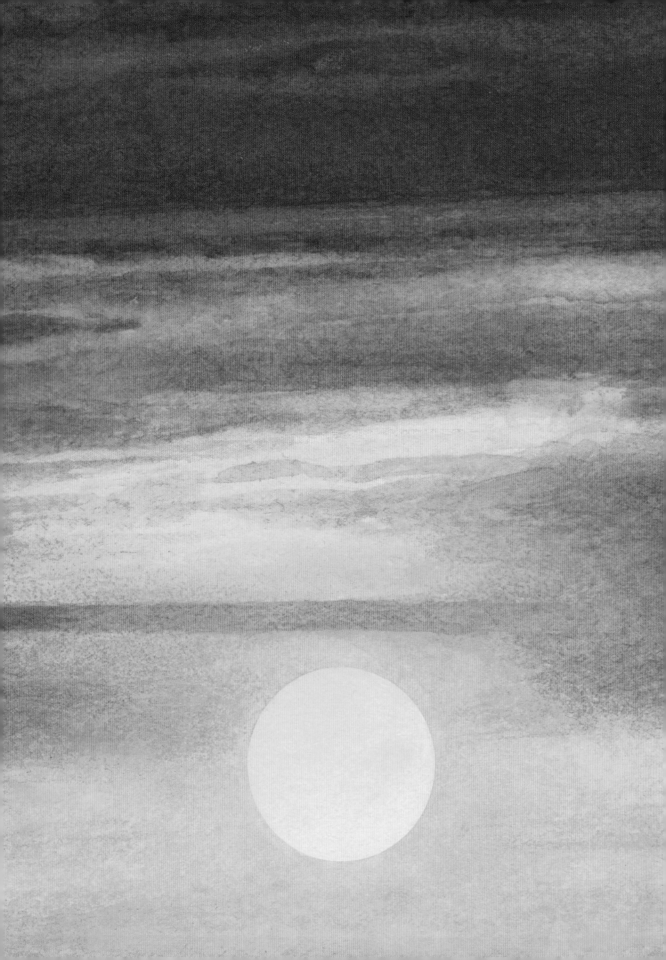

SUNSET

A
final
watercolour

The day begins to draw to an end, and the garden fills up with magic, with hummingbirds flying around in erratic directions and feeding on flower nectar before nightfall. In the Andes, *colibrí*, usually the Spanish word for a hummingbird, also means "resurrection": it is said that they die during cold nights but come back to life at dawn. And this is what Celeste and I have been doing this month: we wake up at first light and stop at sunset. Today we will open a bottle of Californian wine and toast your health. It has been a pleasure to share this day of concentration and slow work with you; I have learned a lot, and I hope that you have too. But we still have one last exercise to complete. ∎

Last
light

The day is ending, and there are only a few minutes of light left in which to finish our final exercise. We will paint the sunset over the sea that Celeste and I are looking at right now. To do this, we will use watercolours, taking into account that they need water to live and that they die in sunlight.

If we want to paint a marine landscape without being by the sea, we can always listen to its sounds on YouTube to create the right atmosphere.

"The strange thing about the sunset is that we actually don't want the sun to set, we want it to stay right on the horizon, not below it, not above it, just right on it."

Mehmet Murat Ildan

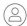

Other artists

Celeste Fichter _
(American, born 1965)

This is a contemporary artist who likes to reorder the ordinary. Using layers of modes of representation, she gives meaning and value to what would otherwise be common and ubiquitous. Humour is a fundamental part of her work. In 2006, she made a magical recreation of a sunset with foil and a bulb—another way of representing reality [A].

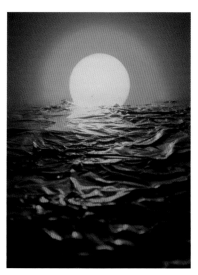

[A] Work by Celeste Fichter.

[1]

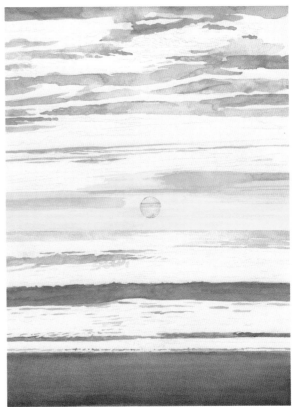

[2]

THE PROCESS

[1] Using the same grid method as we followed in the exercise with the water jar (see page 67), we transfer our drawing of the sunset to the paper.

Before starting to apply watercolours, we erase the grid that we drew on our paper with an H pencil, leaving the lines for the sea view, which are the ones that are of interest to us. Finally, we protect the space for the sun with tape, which we will remove later.

[2] With fairly diluted colours, we produce the first strokes, starting with the strip surrounding the sun, followed by the clouds and waves as well as a base colour for the beach.

[3] We produce a gradation from yellow to red that will go through orange on either side of the sun.

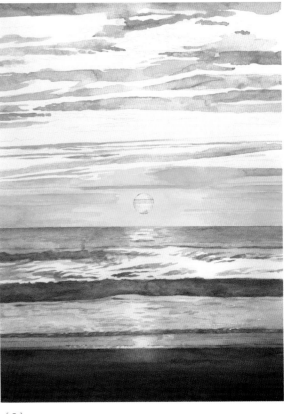

[3]

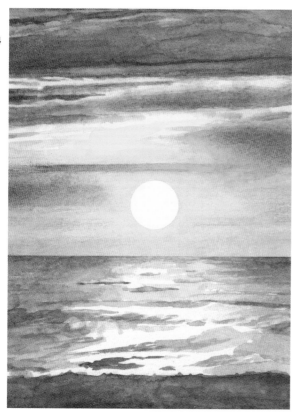

[4]

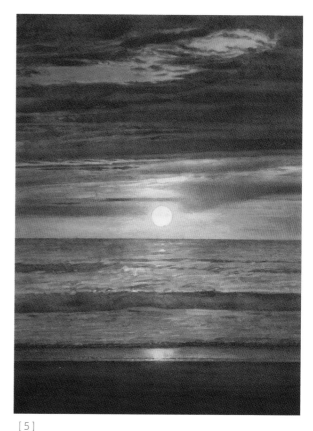

[5]

It is advisable to lighten these colours with yellow (for example, lemon yellow), but not with white (some boxes of watercolours have a white pan), since the latter would diminish the brightness. Our next step is to identify the lights and darks of the sea, using a fine brush to paint the shadows of the waves and their reflections. To understand the hues and tones, it should be kept in mind that in the water we can see the reflection of the sun and the sky that the sun is illuminating.

[4] We will use wet strokes to intensify the warm colours surrounding the sun, and with a dry brush we will soften the yellow-to-red gradation. We now remove the protective tape from the sun, but for the moment we will keep the white of the paper. We will produce the clouds in the sky using diluted layers of colours that vary based on how the warm light of the sun is reflected in the cold clouds. It is a combination of red and blue tones with hints of green.

[5] Using a wet brush for large surfaces and a dry brush for the finishing touches and gradations, we will darken the top of the sky, the sea and the beach, which contrast with the areas of light and add depth to the painting.

[Final step] We will intensify the lights and darks even more, and we will use a dry brush to soften the gradations and achieve the hyperrealist finish that we are aiming for.

Some tips

If we add a little yellow to the sun instead of leaving it white, we will make it brighter.

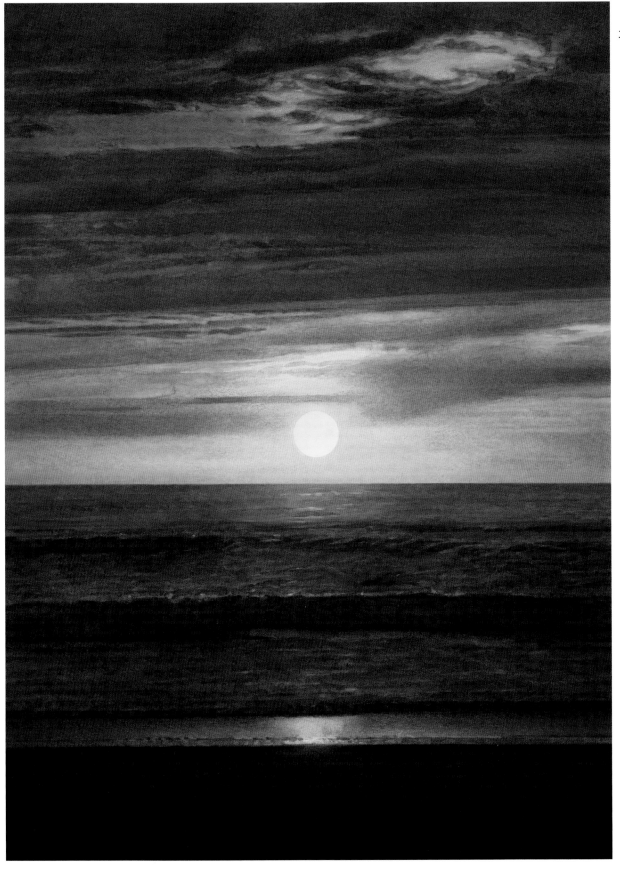

[Last light]

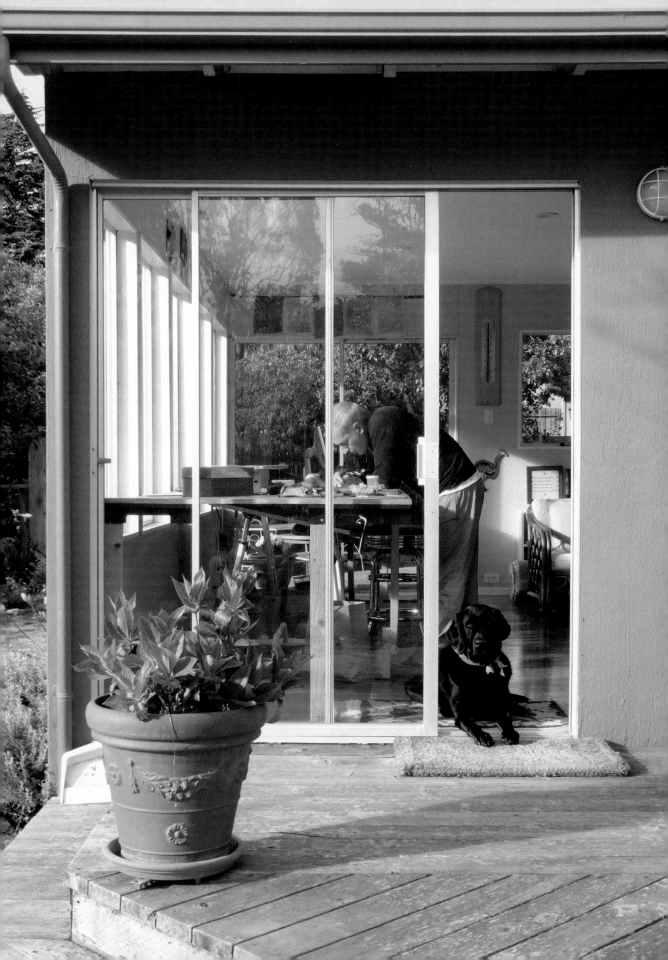

Martí
Cormand

Martí Cormand was born in Barcelona in 1970 but moved in 2002 to Brooklyn, New York, where he currently lives and produces his work. The highlight of his recent work is his pencil drawings and oil paintings that reproduce and reinterpret important works from art history with great precision in their details. He applies the qualities of transparency, density, light, shadow and extreme precision to take the works to a point of self-consciousness. His work asserts the merging of time, or rather the merging of an intangible past that can only be captured in the present through intuition.

Selected international exhibitions:

Really?, **Wilding Cran Gallery**, Los Angeles, California (2017); *Walk the Distance and Slow Down,* **Boulder Museum of Contemporary Art**, Boulder, Colorado (2017); *Postcards to AZ,* **Josée Bienvenu Gallery**, New York (2016); *Martí Cormand,* **Galería Cayón**, Madrid, Spain (2014); *Formalizing Their Concept,* **Galería Casado Santapau**, Madrid, Spain (2014); *Formalizing Their Concept,* **Josée Bienvenu Gallery**, New York (2013); **Fundació Arranz-Bravo**, Hospitalet de Llobregat, Barcelona, Spain (2010); *Martí Cormand: Aldrich Emerging Artist Award Show,* **The Aldrich Contemporary Art Museum**, Ridgefield, Connecticut (2007); Villa Arson, Nice, France (2006).

Works included in the following collections:

The Museum of Modern Art (MoMA), New York; **The Dallas Museum of Art**, Texas; **The Alfond Collection of Contemporary Art**, Rollins College, Winter Park, Florida; **Caja Madrid**, Spain; **Fundació "la Caixa"**, Spain; **Fundació Vila Casas**, Barcelona, Spain; **Progressive Corporation**, Mayfield Village, Ohio; **West Collection**, Philadelphia, Pennsylvania.

The sky grew darker, painted blue on blue, one stroke at a time, into deeper and deeper shades of night.

Haruki Murakami

Dedicated to my parents and Celeste.

Acknowledgements:
Rebeka, Víctor, Bernat, Celeste, Sarah, Jenny, Marco, Joel, Andrea, Elise.